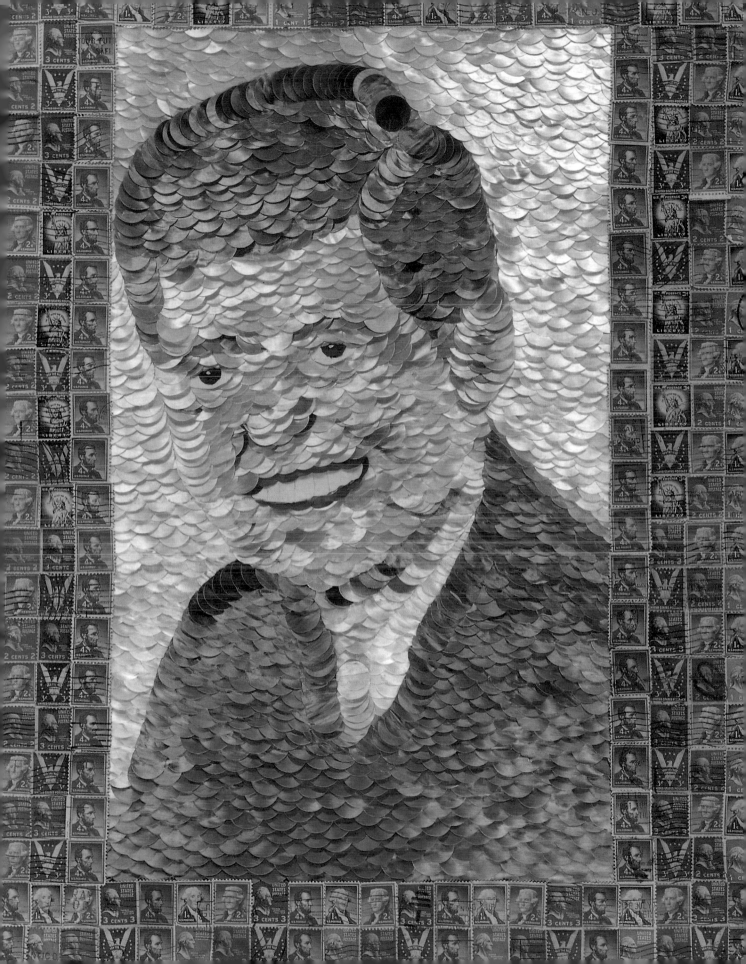

TO THE PRESIDENT

FOLK PORTRAITS

★ BY THE PEOPLE ★

JAMES G. BARBER

THE NATIONAL PORTRAIT GALLERY
SMITHSONIAN INSTITUTION, WASHINGTON, D.C.
& MADISON BOOKS, WASHINGTON, D.C., 1993

Cover illustration: Carved coconut head of Harry Truman.
Harry S. Truman Library

Page 1: Ribbon-and-stamp portrait of John F. Kennedy
by Dora Blackburn of Baltimore, Maryland (detail).
John F. Kennedy Library and Museum. Illustrated in full
on page 46

Facing page: Stamp collage of Dwight D. Eisenhower by
Renier Georges of Lisieux, Normandy, in France (detail).
Dwight D. Eisenhower Library and Museum. Illustrated
in full on page 41

★ ★ ★

Library of Congress Cataloging-in-Publication Data
Barber, James, 1952–
 To the President: folk portraits by the people / James G.
Barber
 p. cm.
 Exhibition catalog.
 "In association with Madison Books."
 Includes bibliographical references and index.
 ISBN: 1-56833-023-5 : $19.95
 1. Presidents—United States—Portraits—Exhibitions.
2. Outsider art—United States—History—20th century—
Exhibitions. I. National Portrait Gallery (Smithsonian
Institution) II. Title.
N7593.3.B37 1993
704.9'423'0973074753—dc20 93-29411
 CIP

Published by Madison Books
4720 Boston Way, Lanham, MD 20706

Printed in Singapore

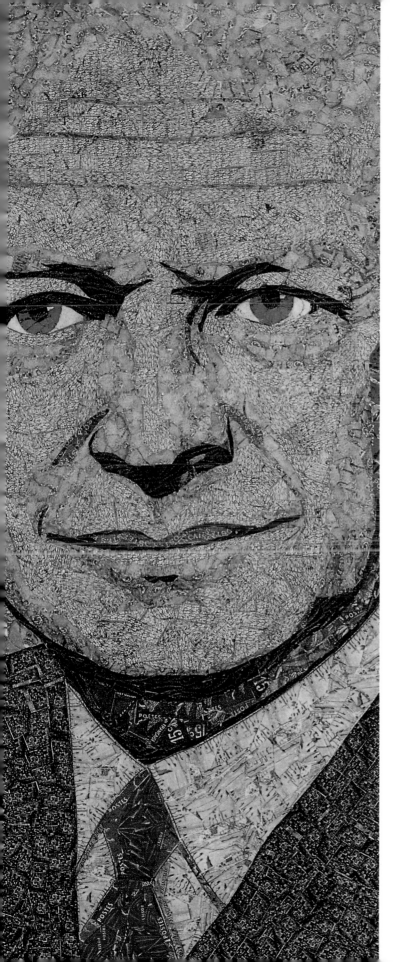

★ CONTENTS

6 ACKNOWLEDGMENTS

7 LENDERS TO THE EXHIBITION

9 FOREWORD BY ALAN FERN

15 INTRODUCTION

THE PRESIDENTS

20 Herbert Hoover

24 Franklin D. Roosevelt

34 Harry S. Truman

40 Dwight D. Eisenhower

46 John F. Kennedy

50 Lyndon Baines Johnson

56 Richard M. Nixon

64 Gerald R. Ford

70 Jimmy Carter

74 Ronald Reagan

80 George Bush

86 Bill Clinton

90 PRESIDENTIAL LIBRARIES

92 NOTES ON SOURCES

93 FOR FURTHER READING

94 INDEX

ACKNOWLEDGMENTS

This exhibition of presidential portrait gifts, from Herbert Hoover to Bill Clinton, would not have been possible without the generous and enthusiastic cooperation of the presidential libraries, the National Archives, and the White House. I am particularly grateful to the following individuals for their kind assistance: Joan D. Maske and Scott Allen Nollen, Hoover Library; Alycia J. Vivona, Roosevelt Library; Benedict K. Zobrist and Clay R. Bauske, Truman Library; Dennis H. J. Medina and Marion Kamm, Eisenhower Library; David F. Powers and Gertrude W. Markell, Kennedy Library; Patricia Burchfield, Johnson Library; Walton H. Owen, Nixon Presidential Materials Project, National Archives; Scott P. Houting, Ford Museum; Sylvia Mansour Naguib, Carter Library; Ann Bethel, Pamela Nett, and Marilyn Morrison, Reagan Library; Mary Finch, Bush Presidential Materials Project, National Archives; Doug Thurman, National Archives; Betty C. Monkman, Timothy Flynn, and Michelle Houston, White House; Frank J. Aucella, Woodrow Wilson House Museum. From within the National Portrait Gallery itself, much-appreciated assistance was rendered by Beverly Cox, Claire Kelly, and Vandy Cook in the Exhibitions Office; Mary Gonzales and Karen Jensen in the History and Curatorial offices; Frances Stevenson and Dru Dowdy in the Publications Office; Rolland White in the Photographic Services Office; and summer intern Ivan P. Kerbel. ★

James G. Barber

LENDERS TO THE EXHIBITION

George Bush Presidential Materials Project, College Station, Texas

Jimmy Carter Library, Atlanta, Georgia

Dwight D. Eisenhower Library and Museum, Abilene, Kansas

Gerald R. Ford Library and Presidential Museum, Grand Rapids, Michigan

Herbert Hoover Presidential Library, West Branch, Iowa

Lyndon Baines Johnson Library and Museum, Austin, Texas

John F. Kennedy Library and Museum, Boston, Massachusetts

Richard M. Nixon Presidential Materials, National Archives, Washington, D.C.

Ronald Reagan Presidential Library, Simi Valley, California

Franklin D. Roosevelt Library, Hyde Park, New York

Harry S. Truman Library, Independence, Missouri

The White House Gift Unit, Washington, D.C.

"REMEMBER"
PEARL HARBOR

DEC. 7 1941

Most of the portraits shown at the National Portrait Gallery have been the product of a direct relationship between an artist and a subject. American presidential portraits were commissioned for official display, and images of chief executives who were particularly esteemed were produced to meet public demand. Whatever the ultimate use, the vast majority of the portraits in the Gallery's collections and exhibitions have represented an interaction between the portrayer and the portrayed. The portraitist was a professional artist, and the portrait reflected an informed response (sometimes positive, occasionally unenthusiastic) to the personality and presence of the sitter.

In contrast, the portraits presented here represent a new departure for the Gallery. Most of them are by amateur artists, few of whom had ever actually seen the President they portrayed, and thus they suggest an entirely different relationship between the portraitist and the subject. These were made out of affection and respect as spontaneous offerings, not as commissioned works, and they were sent to the President as a gift from an admiring citizen. Often surprising in conception, frequently ingenious in the use of unconventional materials, these portraits speak eloquently about the unique place of the American presidency in the national consciousness.

A gift is the tangible expression of a relationship — or a desired relationship — and gifts to and from Presidents have accompanied the office from its very beginnings. Early on, the new United States established a tradition of giving gifts to the Indian nations with whom we treated. The British and French monarchs had conferred medals upon the Indian leaders with whom they established bonds, and the head of the newly established republic followed suit. The George Washington peace medal shows the President offering a gesture of conciliation to a peace-pipe smoking Indian, whose tomahawk has been dropped to the ground. The silver medals were often pierced, so they could be worn; they were treasured by the recipients, often being affixed to elaborate neckpieces, and preserved for future generations in leather or buckskin cases.

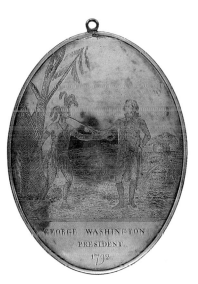

In 1792 President Washington presented this silver medal by an unidentified artist to the Seneca chief Red Jacket. 17.5 x 13.4 cm. (6⅞ x 5¼ in.) oval. Buffalo and Erie County Historical Society, Buffalo, New York (not in exhibition)

Tooled leather portrait of Roosevelt by Robert L. Brown of Hollywood, California, 1942 (detail). Franklin D. Roosevelt Library. Illustrated in full on page 33

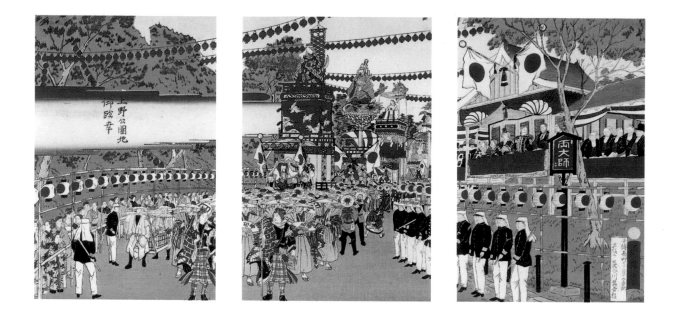

Portraits were used as gifts in other ways, both personal and governmental. Martha Washington gave a miniature of the President to his nephew, Bushrod, who later presented it to Simon Bolivar, the great South American liberator, as a token of mutual respect and shared political ideals. And Washington received portraits as gifts. One came in 1789 from a Mr. and Mrs. Anderson of New York, who presented him with a portrait of their twins born in 1775, named George and Martha after the Washingtons.

Not all gifts to Presidents were portraits, of course. Thomas Jefferson and Andrew Jackson were given enormous cheeses and quantities of other foods. Franklin Pierce was the recipient of many gifts from Matthew Perry's expedition to Japan, and these attracted so many viewers that they had to be moved out of the White House to the Patent Office (the building in which the National Portrait Gallery now resides) to accommodate the curious public. A menagerie of animals ranging in size from the miniature Pekingese "sleeve dog" given by Commodore Perry to Pierce to at least three elephants (President Lincoln tactfully declined a Siamese elephant, but other Presidents were more accommodating) have taxed the ingenuity of recipients throughout American history. On the official level, there is an element of reciprocity in gift-giving. At times (as with the King of Siam's proffered elephants, or the luxury automobiles sent by President Nixon to Leonid Brezhnev) these gifts have escalated to an embarrassing level of lavishness. But over the years, as attitudes have evolved and shifted, repeated attempts have been made to limit the scale of gifts received and given, both for reasons of economy and for ethical reasons, and today these gifts tend to be more modest personal or cultural souvenirs.

While no President (or government official at any level) may retain a gift of substantial value for personal use, the gifts continue to arrive. Some of these are the residue of an official visit, but the vast majority are unsolicited offerings from the public that cannot be limited or controlled in the way a diplomatic

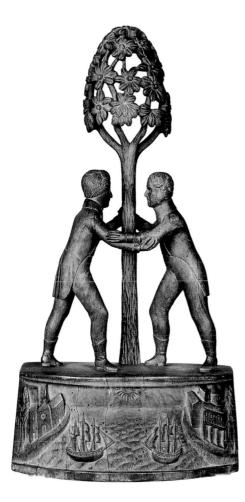

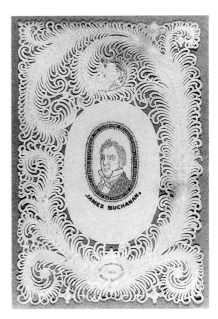

To mark the opening of the first transatlantic cable in 1858, David Davidson executed this paper doily bearing a calligraphic likeness of President James Buchanan. The President's pen-and-ink image is composed of the first official telegraphic exchanges between himself and England's Queen Victoria.
42.7 x 11.1 cm.
(16¹³⁄₁₆ x 4⅜ in.).
The James Buchanan Foundation for the Preservation of Wheatland, Lancaster, Pennsylvania
(not in exhibition)

In 1836 the United States successfully negotiated monetary claims against France for depredations suffered by American shipping interests during the Napoleonic wars. In recognition of this event, folk artist Pierre Joseph Landry, a French immigrant living in Louisiana, executed this wood carving of President Andrew Jackson and King Louis Philippe clasping arms amicably around a tree, symbolic of peace. Allegedly the artist presented this sculpture to President Jackson.
64.8 cm. (25½ in.).
The Hermitage: Home of President Andrew Jackson (not in exhibition)

The provenance of this folk wood carving of Benjamin Harrison is unknown, but it is dated 1888, the year he won the presidential election.
24.1 cm.
(9½ in.) height.
National Portrait Gallery, Smithsonian Institution (not in exhibition)

presentation can be negotiated, and these public donations come in at an astonishing rate. No one can be prepared for the quantity of gifts on display (or in storage) at the various presidential libraries and museums, or to imagine the number of objects flowing into the rooms in which currently received gifts are examined and sorted. Nothing speaks more clearly about the nature of celebrity in American politics than these unsolicited presents from grateful citizens to the President — evidence that people are impelled to speak directly to their President by sending their image of him. The gifts are occasionally in doubtful taste or of limited usefulness, but often of superlative craftsmanship and high ingenuity.

This exhibition and publication are not the place for speculation on the anthropology or psychology of this phenomenon, but a few general conclusions suggest themselves. These gifts from the people do not represent a response to any official obligation, in contrast to the reciprocity involved in the diplomatic exchange of gifts. Perhaps a few of these donors would like something in return — a job, some attention, at least a note of thanks — but many more appear to be making their donation without thought of personal gain. Some ancient societies demanded the payment of tribute to the state, but the portraits here are tributes of a different sort. They have been offered willingly and affectionately. Ever since Washington left the presidency, most Presidents have had as many detractors as admirers, yet the gifts have continued to arrive, in prosperous times and in difficult periods. It leaves us to wonder whether the citizens of any other nation are as respectful and admiring of their head of state, while retaining as vigorously skeptical a view of politics and politicians as does the American public.

The concept of this exhibition was prompted by an article in the December 1990 *Smithsonian* magazine, written by W. Eric Keller, which featured many of these gifts. James Barber has done a splendid job in bringing together a fascinating selection of these generously offered portraits, which (one can only imagine) have been received with a combination of gratitude and astonishment by the Presidents and their staffs. We are grateful to the people in the Executive Office of the President, in the National Archives, and in the several presidential libraries for their willing cooperation in bringing these fascinating objects together.

Alan Fern
Director, National Portrait Gallery

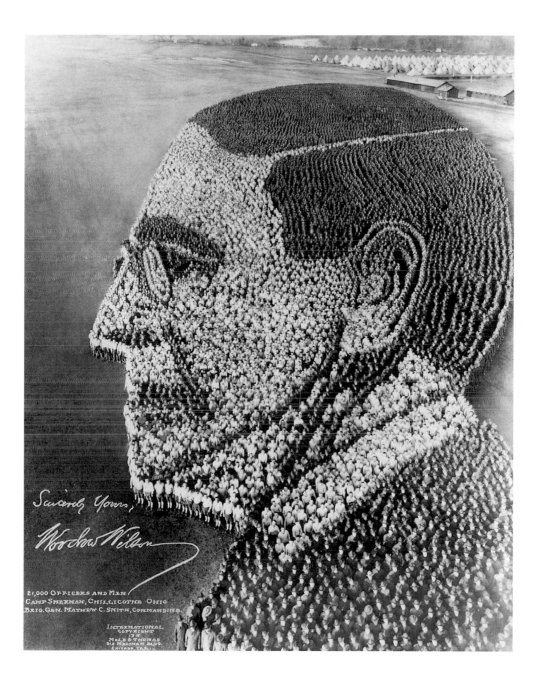

Sincerely Yours,

Woodrow Wilson

21,000 OFFICERS AND MEN /
CAMP SHERMAN, CHILLICOTHE, OHIO
BRIG. GEN. MATHEW C. SMITH, COMMANDING.

INTERNATIONAL
COPYRIGHT
1917
MOLE & THOMAS
312 NEEDHAM BLDG.
CHICAGO, ILL.

On October 31, 1918, twenty-one thousand army officers and men at Camp Sherman, Chillicothe, Ohio, assembled under the direction of designer John D. Adams to form this unique image of President Woodrow Wilson. His profile measured 710 feet in length and 210 feet at its greatest width. From a tower seventy-five feet high, Arthur S. Mole of the Chicago photographic firm Mole and Thomas took this photograph. It was included in a photograph album of similarly designed patriotic images that the firm presented to President Wilson. 33.3 x 25.9 cm. (13⅛ x 10³⁄₁₆ in.). Woodrow Wilson House Museum, National Trust for Historic Preservation, Washington, D.C. (not in exhibition)

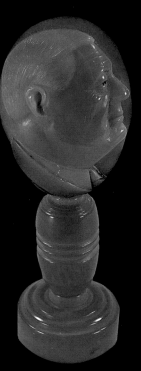

This small profile relief of Franklin Roosevelt was carved by an unidentified artist from an ivory nut, the seed of a South American palm, used to make buttons and ornaments.
11.4 cm.
(4½ in.) height.
Franklin D. Roosevelt Library (not in exhibition)

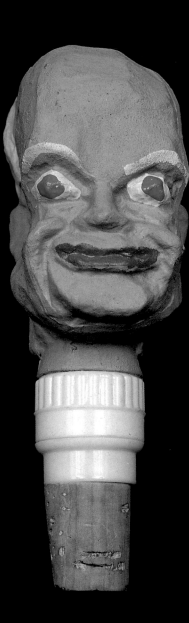

While traveling in France, Mrs. Bee Mitchell of New York City discovered this unique papier-mâché bottle stopper bearing Dwight Eisenhower's likeness. Although Eisenhower had been retired for more than three years, this gift was typical of the affection bestowed upon him until his death in 1969.
13.3 cm.
(5¼ in.) height.
Dwight D. Eisenhower Library and Museum (not in exhibition)

A favorite curiosity in all of the presidential libraries is the portrait gift, the subject of this exhibition and catalogue. The focus here is not on the formal portraits presented as quintessential images for posterity's sake, but on what might be regarded as folk likenesses by amateur artists, such as the postage-stamp collage of Dwight Eisenhower or the fingernail portrait of Ronald Reagan. Harry Truman once complained to a relative that he got mostly photographs of foreign dignitaries in silver frames autographed in strange languages, which he could not understand, while his wife and daughter received "the pretty things." One has to wonder what he thought of the carved coconut bust of himself, which he received at the Truman Library in 1962.

The President of the United States has always represented many things to many people, and this is no more in evidence than in the hundreds of gifts now housed in the nine presidential libraries throughout the country. Franklin Roosevelt, the only President to serve more than two terms in office, was the first to realize the need for a presidential library in which to deposit his memorabilia, in addition to the voluminous papers that comprise the official record of his historic administration. It was his ambition to build such a facility at his own expense on his Hyde Park estate overlooking the Hudson River. Although the idea was novel, it was perfectly natural for an avid collector of Roosevelt's interests and appetites. Stamps, books, ship models, nautical prints and paintings, and bric-a-brac of almost every description — Roosevelt gathered it all until 1939, when finally even he had to lament, "I have no more wall space." Fortunately, the following year his completed library would catch the overflow.

In one sense the story of presidential gifts, portraits or otherwise, is the story of the modern presidential library and museum. Roosevelt's precedent took hold with his followers as well as with his immediate predecessor, Herbert Hoover. In 1955 the Presidential Libraries Act authorized the federal government to accept, preserve, and house the papers and historical memorabilia of the Presidents. In 1971, Lyndon B. Johnson dedicated the largest and most expensive library up to that time. Located on the campus of the University of Texas at Austin, this windowless marble monument to the thirty-sixth President rises eight stories tall and has a helicopter landing pad on the roof. In comparison to FDR's Dutch Colonial style structure, which blends inconspicuously with neighboring inns and motor lodges of Hyde Park, the Johnson Library is colossal. Political cartoonist Herblock once dubbed it the "Great Pyramid of Austin." It houses thirty-one million papers, a manuscript collection fifteen times larger than Roosevelt's. Most visitors would

agree that this museum and research facility fits the man whom many considered to be larger than life, whose social vision and political agenda for America were nothing less than a Great Society, in which there would be equal opportunities and justice for all.

The Ronald Reagan Library is the newest in the presidential libraries system, which is administered by the National Archives and Records Administration. Set dramatically on a high ridge, amidst the beauty of California's Simi Valley, this mission-style structure combines the grandeur of Johnson's library with the architectural aesthetics of Roosevelt's. The next library to be built will be George Bush's, and he has designated Texas A&M University at College Station as its future site. In all probability the concept of the presidential library is here to stay, and it will be anyone's guess as to what future places will someday become national historic sites.

As one might expect, the presidential libraries evoke the individuals for whom they were built, principally in their collections and exhibitions. A case in point is a certain file cabinet in storage at the Harry S. Truman Library in Independence, Missouri. A look inside reveals several army uniforms of World War I vintage, which hang with such precision and crispness that they appear as if they had just come back from the cleaners. When asked if they had, the curator replied no, that was just the way President Truman had left them. What else could be expected of the former National Guardsman turned haberdasher, who was voted one of the ten best dressers in the Senate?

Homespun and whimsical might best describe this genre of attic art, cellar craft, and "avant-garage" sculpture, made from seemingly every conceivable material. From the food groups alone, rice, bean pods, Brazil nuts, eggshells, peach pits, and tropical fruit have been used in one manner or another. One group of grade-school children made a portrait of Ronald Reagan with jelly beans.

Assorted technologies have also left their mark on the presidential image. Portraits made with typewriters were given to Herbert Hoover, Harry Truman, and Lyndon Johnson. Compared to traditional pen-and-ink drawings, these staccato images resemble the illustrations produced by early fax machines. Twenty years after the laser was invented, Jimmy Carter was the first President to receive a laser carving of himself. He was also the only President to have had his likeness sculpted with a chain saw. How different were the technique and temperament of the artist who whittled a matchstick likeness of Richard Nixon! And was it inspiration or mischief that prompted a twelve-year-old girl one sunny day to make a wood burning of Nixon's image with a magnifying glass?

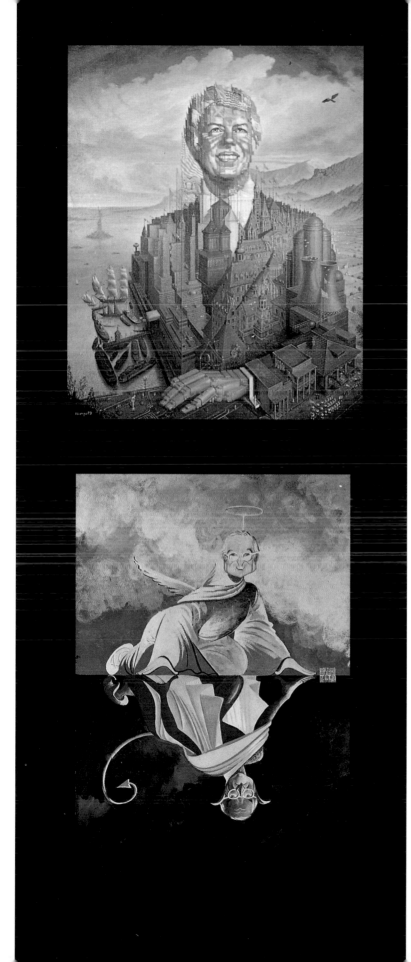

This unusual oil on canvas portrait, composed of a myriad of American sites and icons — notably Jimmy Carter's boyhood home, his father's dry-goods store, the Statue of Liberty, and Philadelphia's Independence Hall — was the work of Mexican artist Octavo Ocampo. President López Portillo of Mexico presented it to Carter before a state dinner at the White House on September 28, 1979. This portrait is now a favorite attraction at the Jimmy Carter Library and Museum in Atlanta, Georgia. 119.4 x 99 cm. (47 x 39 in.). Jimmy Carter Library (not in exhibition)

In March 1951, *Pageant* magazine featured a pair of articles exploring the "two views of Harry Truman." This reversible illustration was published on the magazine's back cover, revealing the Democratic and Republican parties' opinions of the President. Truman of course would have been the Democratic candidate had he run for a second term in 1952. This original (1951) tempera-on-paper sketch by New York illustrator Al Hirschfeld — entitled *The Real Harry Truman?* — was the gift of *Pageant* magazine's promotion director. 69.2 x 52.4 cm. (27¼ x 20⅝ in.). Harry S. Truman Library (not in exhibition)

More than just being amusing images, certain portraits in many subtle and sometimes obvious ways tell us about the Presidents themselves. Among the extensive holdings in the Roosevelt Library are a pair of scrap-metal figurines of FDR and British Prime Minister Winston Churchill made from World War II 37-mm antitank shells. The imagination and skill of the dentist who crafted these images are revealing. A more appropriate material could scarcely have been used to embody the two Allied leaders most responsible for halting fascist aggression in Europe. In the Johnson Library, a wood carving of LBJ seated at a desk studded with pens is symbolic of the man who waged a social revolution against ignorance, poverty, and prejudice, signing bill after bill — 207 in all — including such landmark legislation as Medicare, the Civil Rights Act, Aid to Education, and the Department of Housing and Urban Development.

John F. Kennedy is remembered largely for the vigor and vitality he brought to the presidency. Most of his portrait gifts tend to be idealized icons executed by admirers. As the second-youngest man to take the oath of office, Kennedy succeeded the ailing and grandfatherly Dwight Eisenhower, who was hospitalized for serious illnesses several times during his eight years as President. In reality, Kennedy's own ill health had been a constant worry and vexation for him since childhood. Life-threatening scarlet fever, Addison's disease, and a chronically weak back requiring surgery resulted in his having received last rites several times before he was ever a presidential candidate. Still, the Kennedy image was one of strength, and thus was the impetus behind much of his political agenda, from his Council on Youth Fitness to his resolute Cold War stance toward Russia and world communism.

This exhibition of one-of-a-kind portrait gifts, selected from the collections of the presidential libraries and the National Archives, represents the past eleven Presidents, from Herbert Hoover to George Bush. And so as not to exclude incumbent President Bill Clinton, an effort has been made to represent him from the limited number of gifts received thus far. In this span of more than sixty years, the men in the White House in many respects have been as different as their icons have been original. Still, these icons, exhibited side by side for the first time at the National Portrait Gallery, reveal much about the character and values of the artists themselves. The gifts included here are universally friendly and lighthearted, witty and imaginative, unique and commonplace, inexpensive and irreplaceable. If only Presidents could inspire in all Americans the ingenuity and goodwill of the artists who created these treasures, most of the nation's domestic problems would be resolved with little more effort than it takes to post a letter, crack an egg, or strike a match. ★

Jelly-bean portrait of Ronald Reagan by students at Floyd R. Schafer Elementary School of Nazareth, Pennsylvania (detail). Ronald Reagan Presidential Library. Illustrated in full on page 75

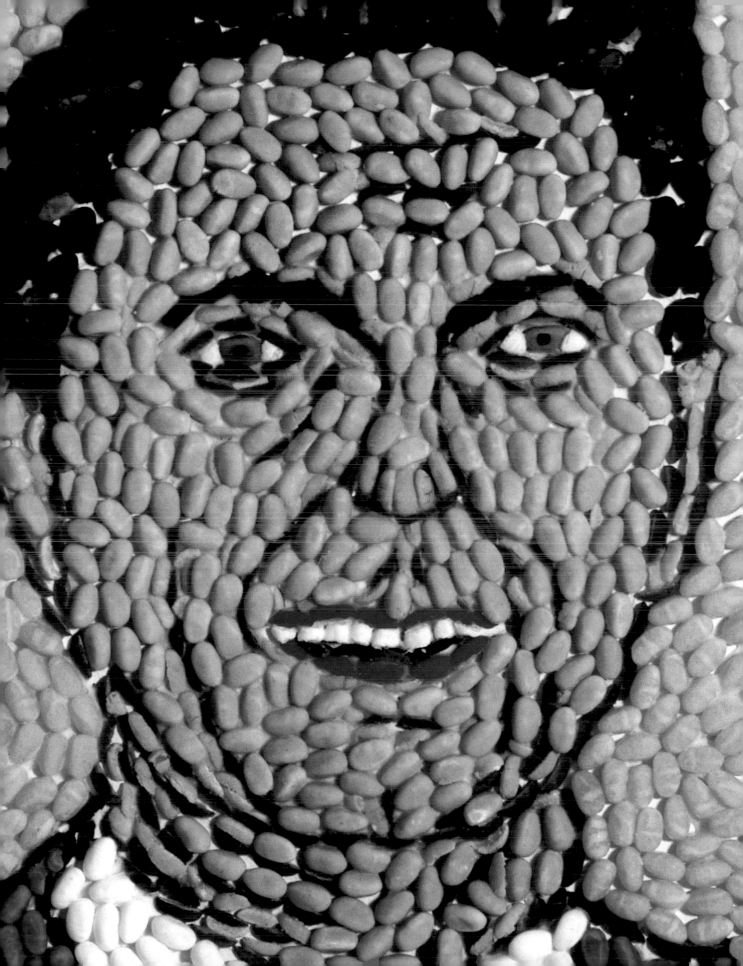

Velvet pillow with portraits of President and Mrs. Hoover by Leff Vartazaroff of Detroit, Michigan, 1929.
45.7 x 61 cm.
(18 x 24 in.).
Herbert Hoover Presidential Library

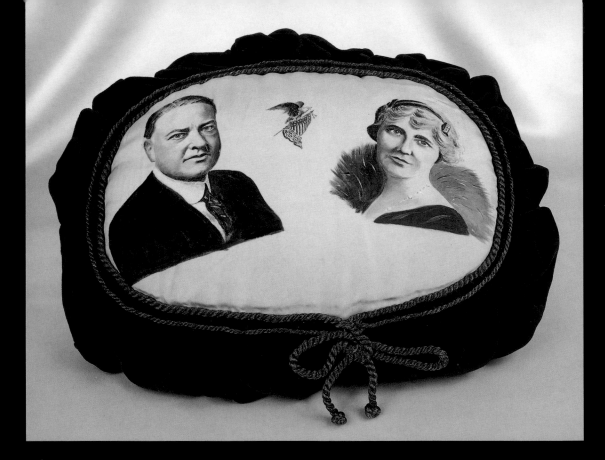

Judging from the dearth of gifts Herbert Hoover received as President, Americans were decidedly not in a giving mood between 1929 and 1933. These were depression years, times of despair for millions of down-trodden Americans and disgruntlement for just about everyone.

Few Presidents had entered office with brighter prospects for continued peace and greater prosperity than Herbert Hoover. Fewer still had been so unlucky. But seven months after he was inaugurated, the bottom fell out of what had been a bullish stock market, precipitating the nation into economic and social chaos. In only a few short years, unemployment soared from a half million in 1929 to thirteen million in 1933. As soup kitchens and tar-paper shanties became part of the national landscape, the country lost faith in its leaders. "No banker, no great industrialist, no college president commands the respect of the American people," observed one disillusioned critic.

Inevitably, Americans turned to the President for answers to the crisis. Based on his qualifications alone, Herbert Hoover seemed to be ideal for coping with the relief task at hand. After all, this was the man who had employed his organizational skills after World War I toward humanitarian causes in battle-scarred Europe. As the head of relief in Belgium, he helped to feed countless thousands in that country alone.

Yet the Great Depression was a different kind of disaster, one that severely tested America's traditional private-enterprise system to restore order and prosperity. There was no greater disciple of that conservative dogma than Herbert Hoover. Born in West Branch, Iowa, and orphaned at the age of ten, the young Hoover inherited little more than a sense of self-reliance and industry, values he was soon to discover were as good as money in the bank. After graduating from Stanford University, Hoover became an international mining engineer and a multimillionaire by the age of forty.

Hoover's rise to world prominence had been methodical; hard work had brought success, and rewards had predictably followed. But as he was to discover as President, formulas for success are often balanced precariously on fate. Nothing in his vast experience could have prepared him for the worst depression in the nation's history. Speaking directly to the President, humorist Will Rogers summed up Hoover's dismal situation in a 1932 radio broadcast: "You just happened to be the man that was left watching the dam when the dam busted, and we expected that you would put the water back."

From the start, Hoover never fully understood the extent of the disaster that had engulfed the country. In this he was like most of his fellow countrymen who were

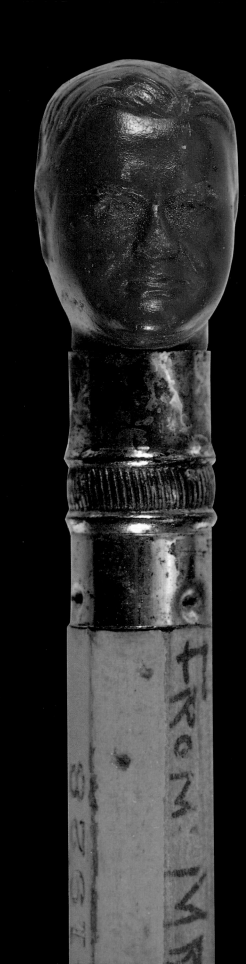

still receiving a paycheck. The President was also philosophi-
cally ill-prepared to consider any kind of direct federal relief
that hinted at being a dole to the American people. He could
justify spending millions for such farm aid as cattle fodder,
but believed that such charities as the Red Cross bore the
responsibility for feeding people. Yet as bread lines lengthened,
even Hoover realized the wisdom of direct government aid to
the distressed. Politically, it was too late for him to salvage
either his reputation as the "Great Humanitarian" or his own
reelection. Hoover vacated the White House a lonely and
bitter man.

Unlike his dynamic successor, Franklin Roosevelt, Hoover
could claim few mementos when his term ended in March
1933. Indicative of the good feelings and prosperity that had
ushered him into office four years earlier was the gift of a
velvet pillow bearing hand-painted likenesses of the President
and the first lady, Lou Henry Hoover. This gift, presented in
May 1929, was from Leff Vartazaroff of Detroit. In a letter
exhibiting perfect penmanship but broken grammar, Mr.
Vartazaroff introduced himself as a former captain of the
Russian Imperial Army who had fled his native country with
the spread of Bolshevism. Now a resident of the United States,
Mr. Vartazaroff was proud to be an American citizen earning
his living by his art.

Success stories such as this were all but taken for granted
before the stock market collapsed a few months later. The
President never personally acknowledged Mr. Vartazaroff's
gift, delegating the task to his secretary. This was characteristic

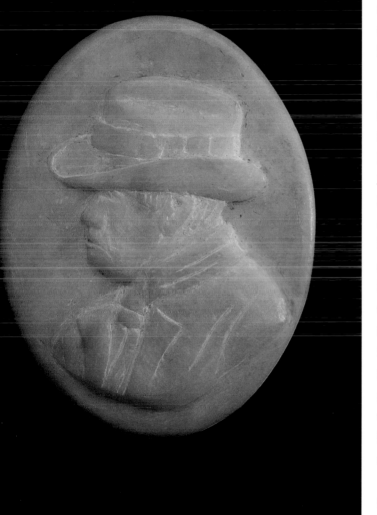

Hoover received this ivory bas-relief carving of himself in 1929 from consulting engineer Charles Evan Fowler of New York City.
6.4 x 3.8 cm.
(2½ x 1½ in.).
Herbert Hoover Presidential Library

1929-1933

of Hoover's stiff demeanor, which during the depths of the depression was interpreted by the suffering populace as indifference to their plight.

Hoover was himself a victim of his stringent monetary and domestic policies when desperate times demanded innovation. On the eve of the 1932 presidential election, *Washington Star* political cartoonist Clifford K. Berryman caricatured Hoover's personal plight in a front-page cartoon titled *President Hoover Gets a Great Kick Out of His Cartoon Collection*. Hoover is shown standing amidst a collage of disparaging cartoons. Typical is the one he holds in his left hand, depicting him as Nero fiddling while the Capitol burns. The sympathetic exception is the one he holds up in the other hand showing him at the wheel of the ship of state. Behind him Uncle Sam extols, "You're steering her right, Herbert." A smiling Hoover expresses his approval with this cartoon and quips, "That one isn't so bad!" Berryman presented the original cartoon sketch to Hoover, as he did seventeen years later with another front-page cartoon in honor of Hoover's seventy-fifth birthday. This work showed Hoover being showered with bouquets of flowers, to which he responds, "Reminds me of 17 years ago — only they were bricks, then."

Indeed, time assuaged much of the public's ill-feeling toward the former President. At the request of Presidents Truman and Eisenhower, Hoover served his country admirably in coordinating European relief efforts after World War II and in organizing the two Hoover Commissions to streamline the federal government. ★

Franklin Roosevelt's bold New Deal prescriptions — farm aid, social security, public-works projects, and federal bank deposit insurance, to name just a few — fell short of reviving the nation from its depression stupor. Still, his leadership went far toward reassuring the beleaguered masses that their plight would not go on forever. As testament to Roosevelt's charisma, he received thousands of letters offering support and encouragement from grateful Americans throughout the country. Intermingled with these accolades were sober handwritten pleas — some addressed to Mrs. Roosevelt — for food and children's clothing. And, occasionally, there were letters offering gifts.

One letter and gift typified Roosevelt's hold on the people. For the President's fifty-eighth birthday, Adolph van Hollander, a Philadelphia interior designer, sent Roosevelt a caricature of him made with copper wire mounted on brown felt and framed under glass. "I wanted to give you something on your birthday," explained Mr. van Hollander, "which would reflect the sense of humor which has carried you through eight difficult years in the White House, and something which would express my belief in the present system of government."

Mr. van Hollander's unusual caricature captured the Roosevelt persona — jutting chin, wide grin, pince-nez, and an air of goodwill and confidence. Roosevelt received dozens of similar gifts that conveyed the people's trust in him and faith in the future. Certain gifts, made with scissors and paste, nuts and bolts, and old newspapers, reflect a depression frugality, whereby the artists relied upon old-fashioned resourcefulness in place of expensive new technologies.

Dr. Bernie Cooper, a Cleveland dentist, was but one example of how the depression prodded all classes of people to rechannel their energies. To fill his free time when his practice dropped off, Dr. Cooper began

Caricature of
Roosevelt worked in
copper wire on felt by
Adolph van Hollander
of Philadelphia,
Pennsylvania, 1940.
52.1 x 41.9 cm.
(20½ x 16½ in.).
Franklin D. Roosevelt
Library

sculpting curious little people out of scrap metal. His patients endorsed his new avocation by bringing him bags of old hardware. Dr. Cooper's garage became his favorite place of employment, to which his neighbors, accustomed to the sounds of drilling, hammering, and sawing, could readily attest. Before long he had a miniature sculpture gallery of figures with heads made of ball bearings and legs and arms made of screws. Notable personalities in his collection included such world leaders as Nationalist Chinese Generalissimo Chiang Kai-shek, Soviet Premier Joseph Stalin, British Prime Minister Winston Churchill, and FDR — all made from scrap artillery shells. In the summer of 1943, Dr. Cooper sent the sculptures of Roosevelt and Churchill to the President with a duplicate set for Churchill. During the next decade, Dr. Cooper enlarged his collection and exhibited it at the Cleveland Museum of Art and the Los Angeles City Museum of History, Science, and Art.

An especially sensitive black-and-white silhouette of FDR, cut by Beatrix Sherman of Chicago, somehow evokes the man and the age of Roosevelt at a glance. As befitting his patrician upbringing in a manor house along the Hudson, Roosevelt is depicted seated in a cushioned parlor chair, with an open book in his hand. His upright posture and crossed legs belie the reality of a man crippled by polio and reliant upon a wheelchair. In spite of the starched white paper cuffs and collar and the handkerchief that protrudes from the President's business suit, the portrait is more familial than statesmanlike.

This work of art was more than just an idle diversion of someone listening to the radio. Sherman was an accomplished silhouette cutter. She cut the profile of FDR in 1934 and most likely presented it to him that year. Exhibitions of her work have been held at the Art Institute of Chicago and the Henry Morrison Flagler Museum in Palm Beach, Florida.

One of the first gifts to be displayed in the Roosevelt Library became an immediate and favorite attraction — a large papier-mâché caricature of FDR as the Great Sphinx. This still-popular curiosity measures seven feet in height (including the detachable pedestal); the face, bearing a Cheshire-cat grin, is forty inches wide. A cigarette holder and cigarette — another FDR trademark — juts from the President's upturned mouth. This gift was presented to FDR by the Gridiron Club, a private organization of Washington correspondents and socialites. It was the centerpiece at their annual dinner and skit in December 1939, at which Roosevelt was the guest of honor. The burlesque targeted the President's sphinxlike silence about his intentions to run for an unprecedented third term in office.

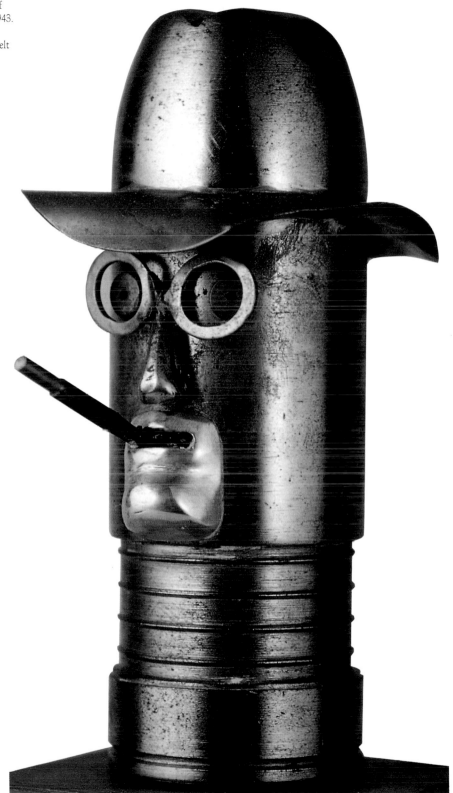

37-mm antitank shell
portrait of Roosevelt
by Bernie Cooper of
Cleveland, Ohio, 1943.
13 cm. (5⅛ in.).
Franklin D. Roosevelt
Library

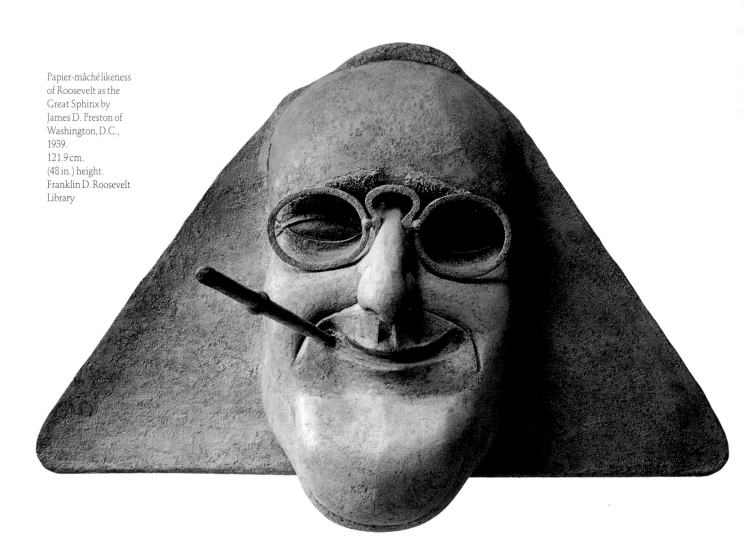

Papier-mâché likeness
of Roosevelt as the
Great Sphinx by
James D. Preston of
Washington, D.C.,
1939.
121.9 cm.
(48 in.) height.
Franklin D. Roosevelt
Library

Who first conceived of FDR as the Sphinx is not certain. On November 16, 1939, a full year before the presidential election, a political cartoon titled *The Sphinx – 1940 Model* lampooned Roosevelt's apparent indecision. Perhaps it was this cartoon by Leo Joseph that inspired the theme for the Gridiron Club's dinner program. The artist of the big papier-mâché sculpture was James D. Preston, a former superintendent of the Senate Press Gallery. Working in his cellar at night, Preston boiled old newspapers in water, making a pulp to which he added flour and glucose. When his papier-mâché was the consistency of putty, he applied it over a frame of wire mesh. For modeling purposes, he acquired two reliable pictures of the President. At critical stages he sought the advice of political cartoonists Raymond Brandt of the *St. Louis Post-Dispatch* and James T. Berryman of the *Washington Star*.

Papier-mâché proved to be an ideal material to imitate stone. No additional coloring was necessary beyond the ink type to achieve a patterned gray stone effect. Noted American sculptor Gutzon Borglum attended the dinner and, seated only forty feet from the smiling Sphinx, remarked that he could not tell for sure that it was not made of stone.

Roosevelt was delighted with the Sphinx and sent it to his library for display and preservation. At least one member of the Hyde Park household, however, was less than enthusiastic about its arrival. Sara Delano Roosevelt, the President's doting mother, was still an influence to be reckoned with at the age of eighty-six. When a White House aide asked innocently if she did not think it was a good caricature of the President, she snapped that she did not think it was at all flattering. The problem was the prominent chin, a trait FDR inherited from his mother.

The Japanese attack at Pearl Harbor on December 7, 1941, galvanized American patriotism to new levels. As commander-in-chief, Franklin Roosevelt became the focal point of the nation's war rally. For the next three years, until his death on the eve of victory, Roosevelt would fill his role with characteristic aplomb. The gift of a framed portrait made entirely of hand-tooled leather acknowledged in an unusual way FDR's leadership in the crisis. In an accompanying letter, the artist, Robert L. Brown of Hollywood, California, explained the art of leather cutting, which had once been practiced by the ancient Mexicans: *I have developed it with a sharpness of line and a cleanness of definition that truly marks all things American. In cutting into leather, there is no retreat. There is no erasing or trying it over. Like the firing of a gun or the swishing of a sabre, it must be right and true the first time.* ★

Small bronze head
of Roosevelt by J. P.
Spoerl, circa 1941.
8.9 cm. (3½ in.).
Franklin D. Roosevelt
Library

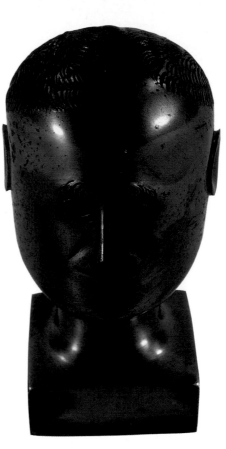

Pipe with carvings of
Franklin and Eleanor
Roosevelt (on
opposite side) by
an unidentified
artist, not dated.
14.9 cm.
(5⅞ in.) length.
Franklin D. Roosevelt
Library

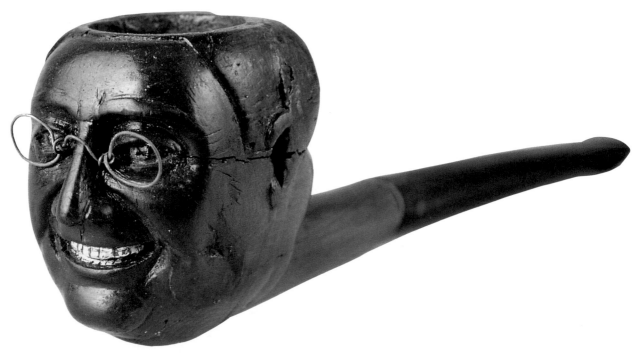

Silhouette of
Roosevelt by Beatrix
Sherman, Chicago,
Illinois, 1934.
29.2 x 21.6 cm.
(11½ x 8½ in.).
Franklin D. Roosevelt
Library

An unidentified artist used, among other things, a Brazil nut, bean pods, and pipe cleaners in assembling this circa 1941 figurine of President Roosevelt wearing a top hat. 10.2 cm. (4 in.) height. Franklin D. Roosevelt Library

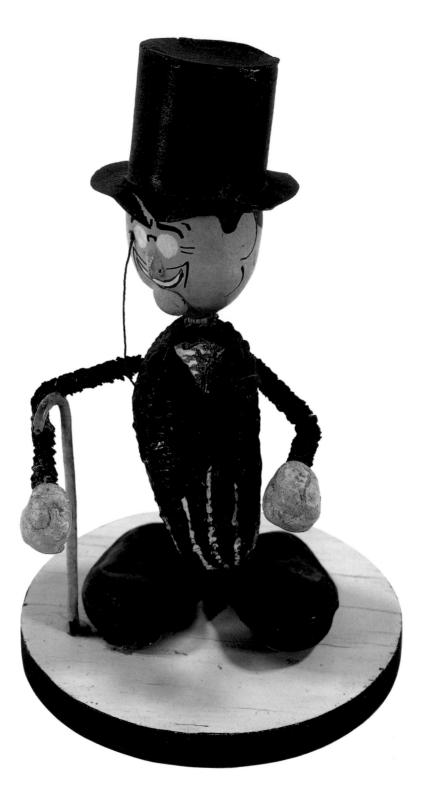

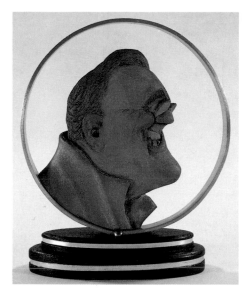

This wooden profile caricature of Roosevelt was carved by an unidentified artist in Mexico and was a gift from Carlos J. Contreras of San Antonio, Texas. Its art deco style was in vogue in the 1930s. 22.9 cm. (9 in.) height. Franklin D. Roosevelt Library

Tooled leather portrait of Roosevelt by Robert L. Brown of Hollywood, California, 1942. 38.1 x 33 cm. (15 x 13 in.). Franklin D. Roosevelt Library

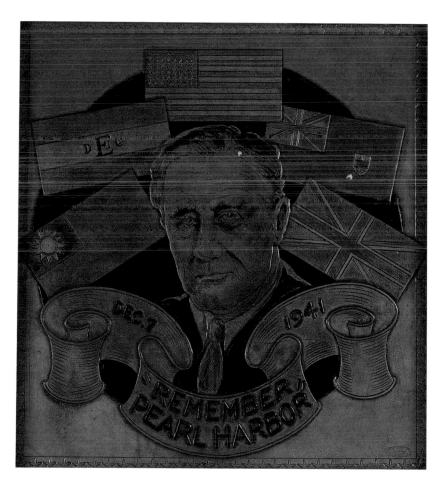

President Harry Truman was once characterized as the "most fabulous accident in American political history." He was also labeled "the greatest American success story any writer could hope to dream up." Indeed, Truman's life had storybook episodes of success and failure, including bankruptcy, foreclosure, and political defeat. As befitting his Missouri upbringing, Truman accepted life as it was in the Midwest with all of its uncertainties. Too poor to attend college, he worked as a railroad timekeeper, bank clerk, farmer, haberdasher, county politician, and judge. He was also a veteran of the Missouri National Guard and the 129th Field Artillery in World War I.

Truman's nomination as Vice President in 1944, against his wishes, surprised most Americans unfamiliar with the dynamics of party politics. Roosevelt himself had to admit that he was merely acquainted with his running mate. That Truman remained something of a mystery to the nation at large was perhaps to everyone's satisfaction at the start, because few men had ever entered the White House as unprepared to assume its awesome duties. Truman had spent ten productive years in the United States Senate, earning laurels for himself as chairman of the Truman Committee, which investigated waste and profiteering in the National Defense Program. But his eighty-two days as Vice President were, not suprisingly, inconsequential. Indicative of his state of mind on April 12, 1945, the afternoon of Roosevelt's sudden death, Truman had been lining up an evening game of poker with a few old friends. Arranging for his personal supply of scotch and bourbon that he kept in his Senate office to arrive at the game site on time — the Statler Hotel near the White House — was as much on his mind as anything else. Obviously, Truman's life instantly assumed new meaning for him, the nation, and the world. If ever a person deserved a stiff drink, card game or no, it was this newly minted statesman from Independence, Missouri.

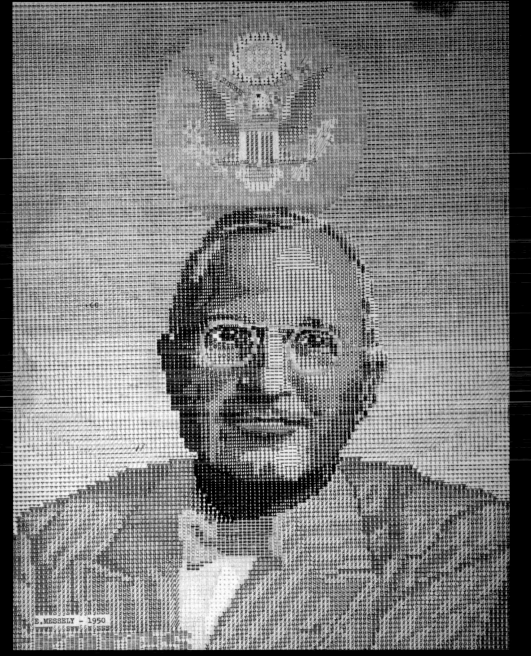

In 1954, the vice
president of Kores
Carbon Paper &
Ribbons
Manufacturing
Corporation of
New York City
sent this colorful
portrait made by
a typewriter to
the retired
President.
44.3 x 34 cm.
(17 $^{7}/_{16}$ x 13 $^{3}/_{8}$ in.).
Harry S. Truman
Library

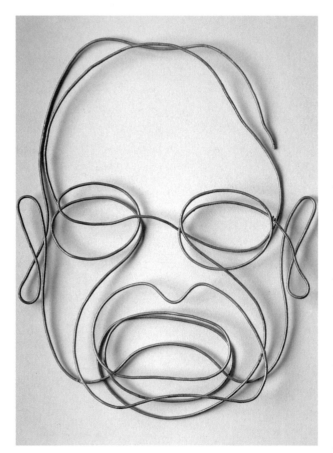

An unidentified artist fashioned this caricature of Truman from a single piece of wire. 29.2 x 22.9 cm. (11¹/₂ x 9 in.). Harry S. Truman Library

During the next eight years, Americans would come to know straight-talking Harry Truman. Truman himself would have a lot to learn. He entered office knowing nothing about the atomic bomb, which he ordered to be dropped on Japan four months later, forever raising the stakes in international relations. About his role at Potsdam, the last World War II conference among the three major powers — the United States, Great Britain, and Russia — Truman admitted, "There was an innocent idealist at one corner of that Round Table who wanted free waterways," while the Russians were coveting most of Eastern Europe. Truman avidly supported chartering the United Nations, and the Truman Doctrine, America's pledge to help free nations resist Soviet aggression, demonstrated further his wisdom as head of state; it became the cornerstone of American foreign policy throughout the Cold War. Truman could also take ample credit for the widely hailed Marshall Plan, which pledged American economic aid to foster freedom in Europe.

Still, the President had his detractors, who felt that he never filled the seat vacated by his illustrious predecessor. Critics charged that Truman was petty, stubborn, and inattentive; they contended that instead of administering the government, he merely presided over a bunch of self-interested, highly paid cronies. Concerning domestic policy, Truman's Fair Deal was no sweeping New Deal, but such underappreciated components of it as civil rights legislation and federal health insurance have proven to be perpetual issues of national concern.

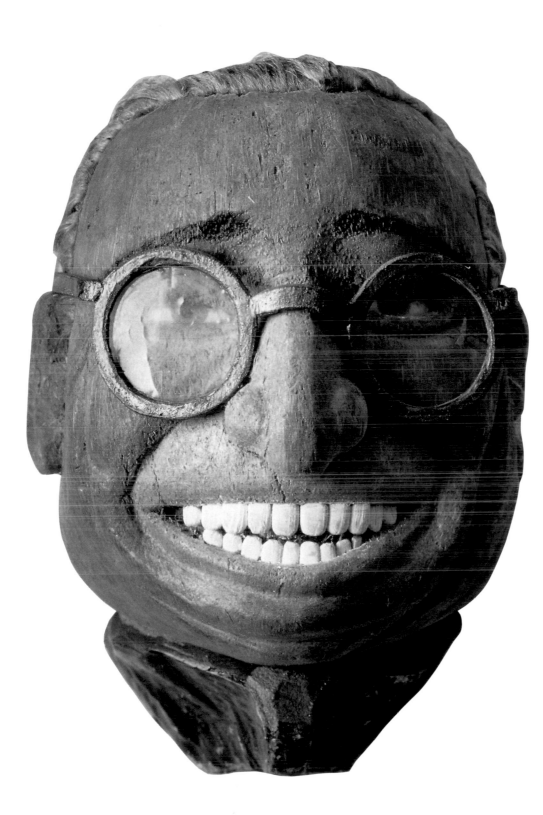

This carved coconut
head (circa 1952) of
Truman was the work
of an unidentified
Puerto Rican
craftsman. It was
acquired by Bryce B.
Smith, mayor of
Kansas City, Missouri,
from 1930 to 1939. In
1962 Smith's daughter
presented it to the
Truman Library.
At the time, President
Truman, seventy-
eight, visited his
office in the library
almost daily.
20.3 cm. (8 in.) height
Harry S. Truman
Library

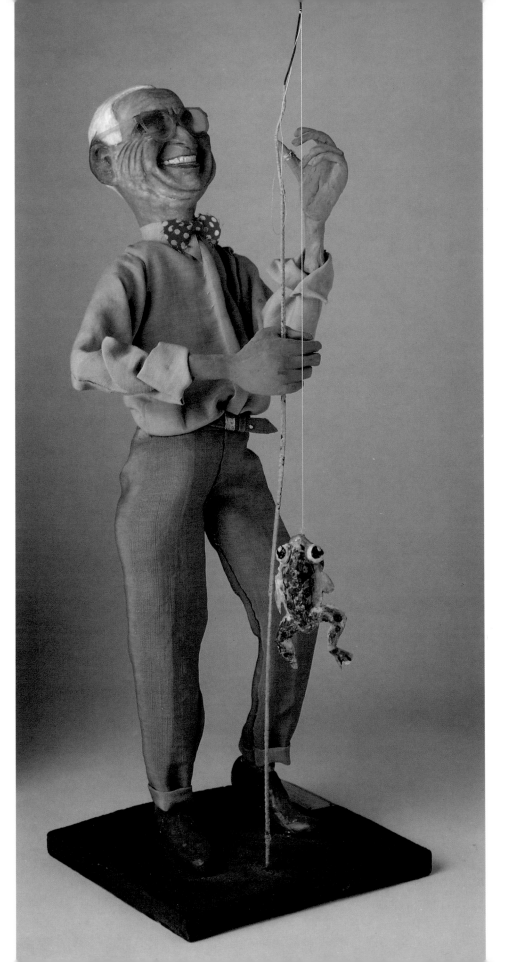

Mixed-media
caricature of Truman
holding a fishing pole
by Christos Diatsintos
of Vienna, Austria,
1948.
45.7 cm. (18 in.) height.
Harry S. Truman
Library

Truman's feistiness with Congress explained some of his failure to enact important legislation, but in other respects he was simply ahead of his time. Not surprisingly, his reputation has steadily improved as time and history catch up to him.

★ ★ ★

Truman's narrow defeat of New York Governor Thomas E. Dewey in 1948 was the occasion for two caricature sculptures. The one of the President holding a fishing pole (left) was executed by a Greek artist living in Austria. During the presidential campaign this figure was exhibited in a window of the Associated Press in Vienna. The artist, hoping to someday immigrate to the United States, sent this gift to Truman after the election.

The wood carving of Truman at the piano (right) was the gift of a South Norfolk, Virginia, hardware man, a loyal Democrat who whittled while listening to Truman's campaign speeches. Truman's love of music, especially of playing the piano, was instilled in him as a youth and was already nationally known when he became President. No less than five pianos graced the White House while the Trumans occupied it. During his political career, as the spirit moved him, Truman played for such distinguished company as Joseph Stalin, Winston Churchill, and Grandma Moses. A famous photograph of Truman as Vice President showed him performing for actress Lauren Bacall, who was perched leggily over the keyboard. This duet raised many eyebrows, including Mrs. Truman's. ★

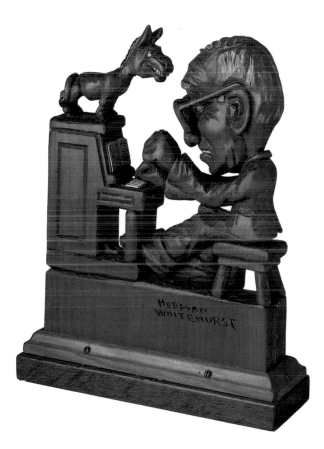

Geniality and popularity will often assure a candidate's success in winning election to the presidency. National prosperity and peace will almost guarantee reelection. During the 1950s, Dwight D. Eisenhower seemingly had it all. As the supreme commander of the Allied victory in Europe, Eisenhower emerged from World War II as its most celebrated hero. His national appeal was enormous, and both political parties sought him as a presidential candidate in 1952. In some respects Eisenhower was a throwback to the administration of George Washington, when the country wanted a man of proven leadership and integrity in place of a politically packaged soothsayer of good times ahead.

Under Eisenhower the nation enjoyed eight years of economic prosperity and peace. Not since the 1920s had there been simultaneous stretches of such good fortune. Americans lived the American Dream to the fullest at the time and learned to appreciate it later as Ike's successors stumbled in one arena or the other. On the domestic front, Eisenhower produced three balanced budgets without dismantling such core New Deal programs as social security, unemployment insurance, and farm aid. In addition, he expanded government in the areas of health, education, and welfare, creating a new cabinet department. His landmark program for a federal system of highways was both practical and visionary as Americans began utilizing the automobile. Eisenhower's record on civil rights was less aggressive. Although he was not the architect of liberal new initiatives, neither did he impede the process of racial parity. He backed the

Renier Georges of Lisieux, Normandy, in France used 6,000 French stamps and spent 350 hours making this collage of Eisenhower in 1956–1957. 66.4 x 54 cm. (26⅛ x 21¼ in.). Dwight D. Eisenhower Library and Museum

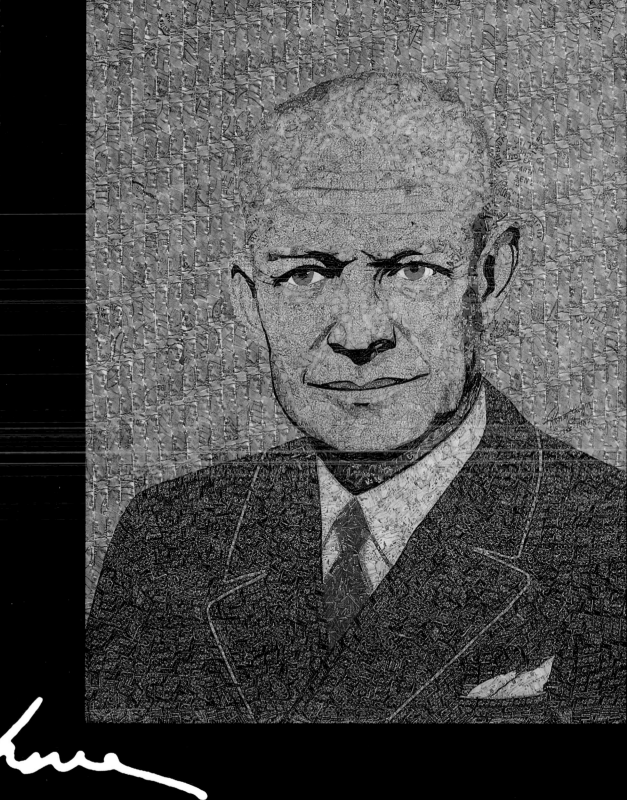

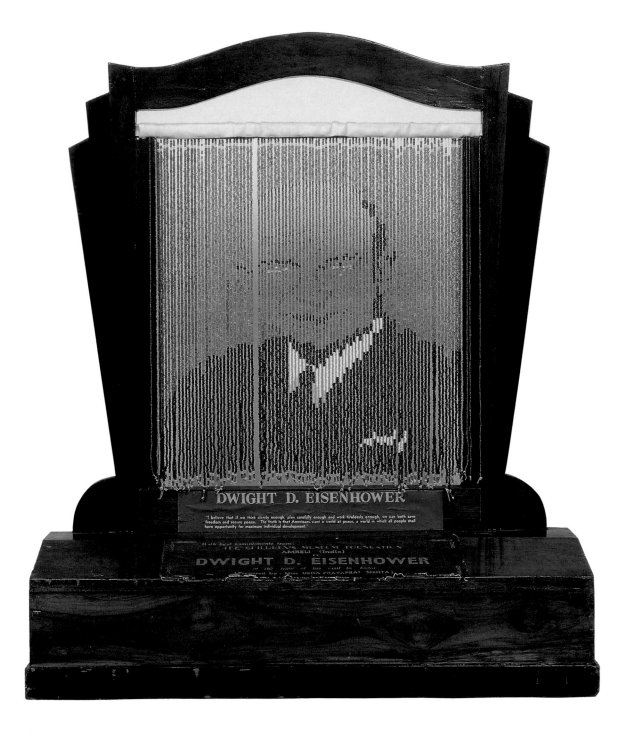

Dwight Eisenhower was the first President of the jet age. In 1959, aboard the new and comfortably equipped *Air Force One,* he embarked upon a goodwill tour of several European, South Asian, and Middle Eastern countries. The trip was an opportunity for the President to reassure America's allies of continued United States support, while giving him the chance to do some long-awaited sightseeing. India especially made an impression upon him, when he contrasted the majesty of the Taj Mahal with the squalor of mass poverty. In recognition of the President's visit, this beadwork portrait was presented to him from Miss Usha Prataprai Mehta of the Children's Museum Foundation, Amreli, India. 65.4 x 54.6 cm. (25¾ x 21½ in.). Dwight D. Eisenhower Library and Museum

Supreme Court's ruling against school segregation by sending the military into Little Rock, Arkansas, in 1957, and he established the United States Commission on Civil Rights.

In foreign affairs, Eisenhower maintained America's postwar military preeminence without inflaming the rhetoric of the Cold War. He ended the Korean War and opposed military intervention in Vietnam. Realizing the consequences of the nuclear arms race, Eisenhower engaged the Soviet Union in new dialogue and warned his fellow countrymen about the dangers of the military-industrial complex.

The severe recession of 1958 and the embarrassing Soviet downing of an American U-2 spy plane during the 1960 Paris summit with Nikita Khrushchev contributed to making Eisenhower's second term less successful. Critics charged that the President was becoming more and more indecisive and that he was delegating too much authority. If leadership was an example, golf and fishing had all but become the national pastimes during the Eisenhower years. Still, Americans never lost faith in the thirty-fourth President. The catchy campaign slogan "We Like Ike" was just as appropriate in 1961, when Eisenhower retired from office, as it had been in 1952, when he was first elected. ★

1953-1961

Dwight D. Eisenhower.
35.6 cm. (14 in.) height.
Dwight D. Eisenhower
Library and Museum

These porcelain figurines, depicting the President and first lady Mamie Eisenhower in their 1953 inaugural ball attire, were made by Sallee Thorne of Monrovia, California. Mrs. Eisenhower's gown is patterned after a swatch of the original fabric sent to the artist by New York designer Nettie Rosenstein. The original gown was of peau de soie, pink with a mauve undertone, embroidered with more than 2,000 pink rhinestones. The first lady wore matching taffeta and crinoline petticoats under the bouffant skirt, and her long pink gloves and shoes were in a matching fabric. The original evening bag was also designed by Rosenstein and was encrusted with 3,456 pink rhinestones, pink pearls, and beads. Mrs. Eisenhower wore costume jewelry designed and made for her by Trifari. In 1955 she presented her gown, accessories, and jewelry to the Smithsonian Institution for display in its popular First Ladies Hall.

Mamie Eisenhower.
25.4 cm. (10 in.) height.
Dwight D. Eisenhower
Library and Museum

In this ribbon-and-
stamp portrait of
Kennedy, made during
the presidential
campaign of 1960,
Dora Blackburn of
Baltimore, Maryland,
somehow managed to
evoke the candidate's
youth and vigor, if not
his regular features.
74.9 x 54.6 cm.
(29½ x 21½ in.).
John F. Kennedy
Library and Museum

As good as life had been during the 1950s, the perception among Americans was that it could still get better. In large part this was the message conveyed in 1960 by the young Democratic presidential candidate, John F. Kennedy. Rich, handsome, and well-bred, the forty-three-year-old Kennedy projected a robust image of dynamism and success. His entrepreneurial father, Joseph P. Kennedy, had demanded excellence in all of his nine children, and his second son seemed destined to fulfill those expectations at the highest echelon of public service. Still, Kennedy's background and experience were questionable; a prominent New England family, a Pulitzer Prize for biography (*Profiles in Courage*), and a lackluster stint in the United States Senate were at best only marginal qualifications for the presidency. In addition, no Catholic had ever before been elected to what traditionally had been perceived as a Protestant-only office. Yet Kennedy politicked with intelligence and charisma, and he exploited the electronic media to his advantage. In a series of televised debates with the Republican challenger — Eisenhower's Vice President, Richard Nixon — Kennedy laid to rest many of the concerns regarding his age and inexperience. His narrow victory in the election was less a mandate for radical change than it was a preference for new and vigorous leadership.

Foreign affairs all but dominated Kennedy's tragically abbreviated term in office. Realizing the limitations of the United States in solving world problems, Kennedy reached out to Third World nations in the interests of democracy and the balance of power. Of his programs offering economic aid and technology to poor countries, the Peace Corps has been Kennedy's most enduring legacy. He inherited the Cold War and saw it escalate to perilous new levels of animosity. In 1961 an American-backed attempt to overthrow Cuba's Communist dictator, Fidel Castro, failed miserably. The next year's Cuban missile crisis directly pitted the United States against its

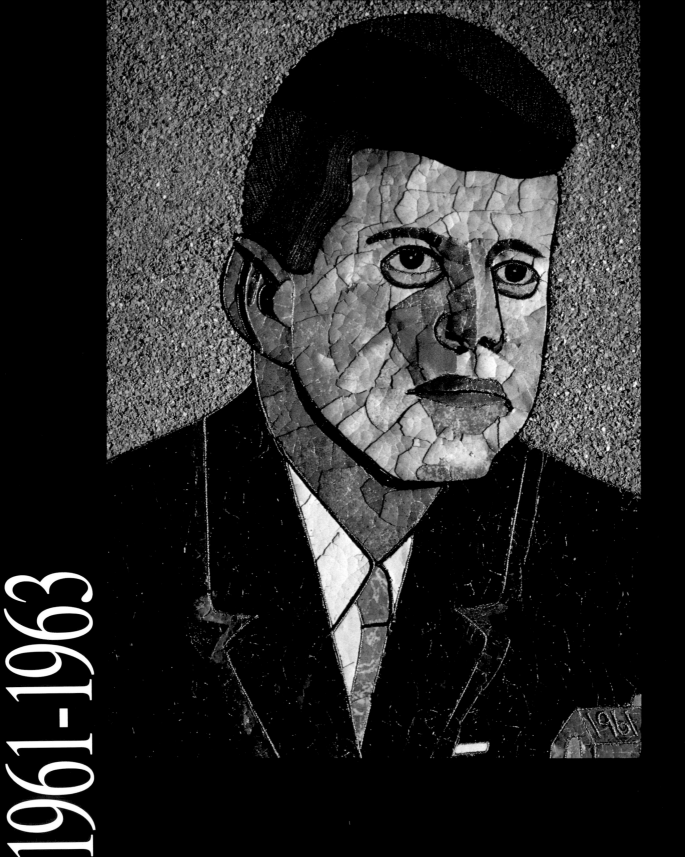

1961-1963

superpower adversary, the Soviet Union. The United States won this contest of wills when the Soviets withdrew their missiles. Yet this confrontation underscored Kennedy's determination to prevent future international misunderstandings that could trigger an apocalypse. The signing of the Nuclear Test Ban treaty in 1963 was a significant peace initiative.

At home Kennedy's commitment to economic policies of expansion contributed to steady increases in the Gross National Product and decreases in unemployment. Although the President's proposals for federal aid to education and medical care for the elderly met stiff resistance in Congress, their passage in the Johnson administration reaffirmed the spirit of Kennedy's New Frontier. The space program and civil rights reforms were two major Kennedy directives that also would not come to fruition until after the President's assassination in 1963. Progress in these areas, as well as new awareness for the arts, humanities, and youth fitness, manifested Kennedy's idealism for the pursuit of excellence and equal opportunities for all Americans. If, during the course of his brief presidency, Kennedy fell short of achieving his ambitions for the country, he did leave a legacy of vision, hope, and promise for future generations. ★

President Lyndon Baines Johnson considered the happiest day of his life to have been the day he left the White House. In some respects, this was an ironic statement for a man who had yearned for political power throughout three decades of public service and, if given the choice, probably would have died in one elective office or another. Johnson had served in the United States Congress for the majority of those years, first as a representative from Texas and then as a senator. He had maneuvered his way up the rungs of power seemingly by the combined forces of his persuasive personality and political instincts. Johnson was a master in the art of cajoling. Indeed, there had not been a better cloakroom tactician in the Capitol since the days of Henry Clay. During the six years that Johnson was Senate majority leader, no significant legislation was passed without his personal stamp of approval.

Upon becoming President after Kennedy's assassination in 1963, Johnson found himself in an office that by its nature was as complex as he was himself. To use an artist's vernacular, Johnson was a mixed-media personality — a combination of many inner drives and emotions. One psychiatrist described him "as a restless, expansive, manipulative, teasing, and sly man, but he was also genuinely passionately interested in making life easier and more honorable for millions of terribly hard pressed working class men and women."

In the wake of tragedy, Johnson pledged himself to unifying the nation and to enacting the social reforms of his predecessor. Passage of the Civil Rights Act of 1964 was a landmark step toward achieving racial equality. Johnson's own domestic agenda, which he called the Great Society, was nothing less than remarkable for a single-term President. Before leaving office, Johnson had signed more than two hundred bills improving the quality of life for just about every element of society, including the poor, the elderly, the sick, college students, farmers, federal workers, and the handicapped. Although much of this legislation was superficially conceived and later proved to be inflationary, certain bills like medicare and food stamps have become established American entitlements.

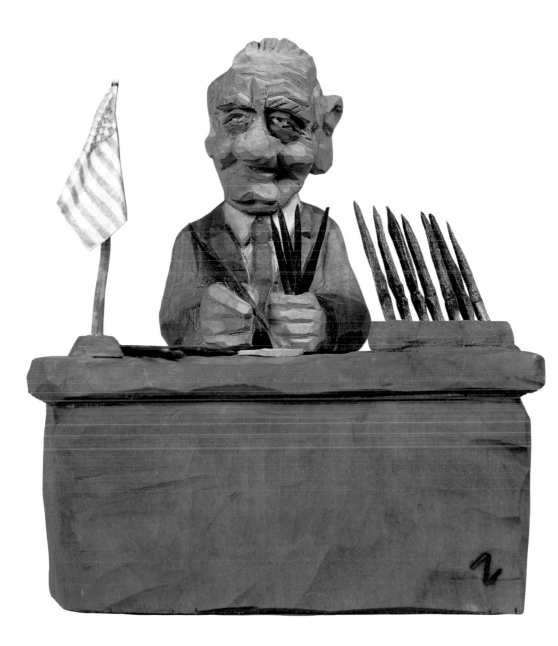

One gift that President Johnson cherished with great pride was not a portrait but a silver desk set presented to him near the close of his administration by members of his cabinet. The pad was inscribed with the titles of 207 pieces of legislation that Johnson had signed into law. "I regarded those laws," wrote Johnson in his memoirs, "not as ends in themselves but as the building blocks of a better America." This wooden caricature carving of Johnson at his desk signing legislation was given to the President by Gene Zesch from Mason, Texas, in 1965.
20.3 cm. (8 in.) height.
Lyndon Baines Johnson Library and Museum

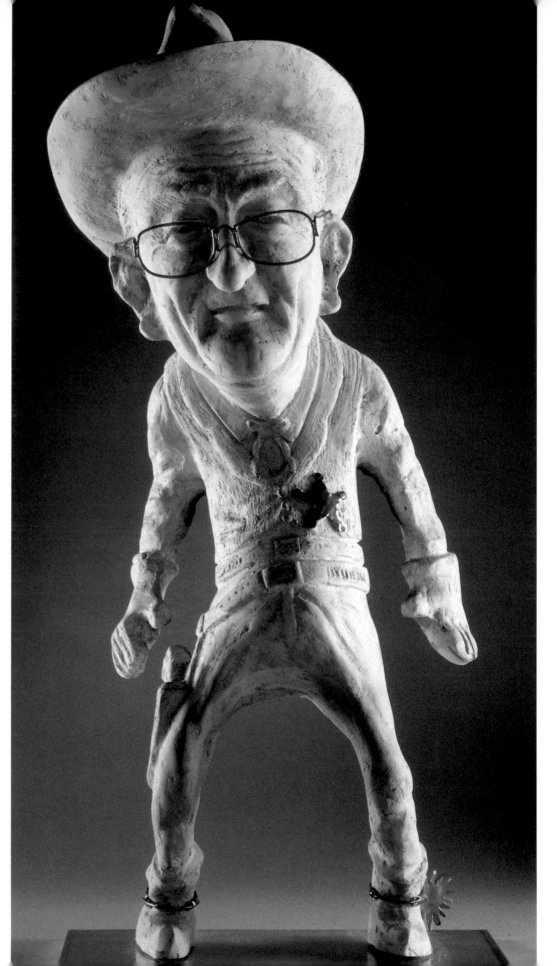

Montreal sculptor Steve Yuranyi made this caricature of LBJ as a lawman out of fiberglass and wire in 1971. His inspiration, however, may have been an editorial cartoon by Jack Jurden of the *Wilmington News Journal*. Titled "Alright You Editorial Cartoonists, DRAW!!," this cartoon of Johnson as a western gunslinger was drawn for the annual meeting of the American Association of Editorial Cartoonists, which met in May 1971 at the LBJ Ranch in Johnson City, Texas. 58.4 cm. (23 in.) height. Lyndon Baines Johnson Library and Museum

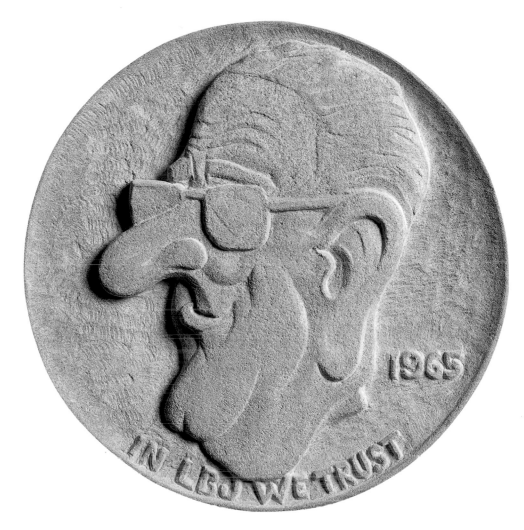

The artist of this large, coinlike caricature carved out of limestone is unknown. The inscription "In LBJ We Trust" reflects the country's confidence in Johnson in 1965, after his landslide election the previous fall 30.5 cm. (12 in.) diameter. Lyndon Baines Johnson Library and Museum

For a politician who had made a career of inflicting his will upon others, Johnson, as President, came to understand that no amount of arm-twisting or back-slapping could necessarily keep the confidence of the American people. Unfortunately, the pride the country had begun to feel in its domestic progress was severely eroded by campus unrest, urban riots, and even political assassinations. America's military involvement in Vietnam had all but created the "credibility gap"; the optimistic reports emerging from the White House somehow never squared with the escalating casualty figures that were reported daily. As commander-in-chief, Johnson accepted responsibility for this war that was morally dividing the nation. Unable to negotiate a peaceful resolution and unwilling to make an all-out military commitment to achieve victory, Johnson became his own prisoner of war. So it was that his standing among the people declined drastically, precipitating, for the man who wanted to be "the greatest President of them all," a bittersweet retirement. ★

These three lighthearted caricatures of LBJ represent the imagination and versatility of Giuseppe Baggi, the native of Faenza, Italy, who seemingly could "make *anything* out of *anything* and usually, in seconds." In the early 1960s Baggi was a middle-aged wanderer making his living by his unique spur-of-the-moment art.

With a pair of scissors, some wire and aluminum foil, perhaps a gum wrapper or some ordinary colored paper, Baggi could bend, twist, and fold the contents of a wastebasket into miniature menageries and human beings of every shape, size, and description. Highlights of his sojourn in America were television appearances on the "Ed Sullivan Show" and the "Mickey Mouse Club." In 1964 he made and presented these portraits to the President.

Paper, wire, and Plexiglas, 1964.
15.2 cm.
(6 in.) height.
Lyndon Baines Johnson Library and Museum

Paper, 1964.
27.9 x 21.6 cm.
(11 x 8½ in.).
Lyndon Baines
Johnson Library and
Museum

Wire on paper, 1964.
27.9 x 21.6 cm.
(11 x 8½ in.).
Lyndon Baines
Johnson Library and
Museum

In his first inaugural address, in January 1969, President Richard Nixon made reference to the orderly change of government that had become an American tradition. Five-and-a-half years later, Nixon resigned the presidency under allegations of misconduct, demonstrating how that profound constitutional theory would work under trying circumstances. Considering the two decades it had taken him to reach the pinnacle of statesmanship, his demise by the Watergate scandal and coverup was almost expeditious. An even greater irony was that Nixon had nothing directly to do with either his entry into national politics or with the fateful Watergate break-in that led to his historic departure. Yet he had everything to do with pushing these processes toward their unforeseeable, and ultimate, ends.

In 1946 Nixon accepted the Republican party's invitation to run for California's Twelfth Congressional District. Shy and introverted as a youth, the thirty-three-year-old Nixon campaigned with surprising combativeness. His decisive victory over veteran New Dealer Jerry Voorhis aroused in him political aspirations that he would pursue almost ruthlessly for the next twenty-eight years. The hard-line anticommunist rhetoric that Nixon had exploited in the campaign, he put into practice as a member of the House Un-American Activities Committee. His probing of Alger Hiss, a minor diplomat with alleged Communist sympathies, resulted in a perjury conviction for Hiss and a national reputation for Nixon.

Yet in subsequent political contests, Nixon would be compelled to defend his own honor and integrity. For his aggressive tactics in winning a Senate seat in 1950, Nixon earned the indelible sobriquet "Tricky Dick." Two years later, a more serious charge was the allegation that Nixon, campaigning for Vice President on Eisenhower's ticket, had had access to a slush fund. In his famous televised "Checkers" speech, Nixon successfully defended himself, but still he bore the taint of suspicion among critics.

Nixon's climb up the political ladder was not without major setbacks. In spite of his dynamic record as Vice President, a traditionally powerless office that Nixon enhanced largely by his diplomatic missions to

Twelve-year-old
Roxanna Yarbrough
of Belvidere,
Tennessee, made this
wood-burning of the
President in 1973 by
holding a magnifying
glass in the sun. She
claimed never to have
had an art lesson.
21.6 x 18.4 cm.
(8½ x 7¼ in.)
Richard M. Nixon
Presidential Materials,
National Archives

Russia and South America, he lost the presidential election of 1960 to the less experienced but more charismatic John Kennedy. This narrow defeat was at least respectable. His humiliating failure to clinch the governorship of California two years later prompted Nixon to forsake a further career in politics. Yet he could never be content with the financial success that went with a partnership in a prestigious New York City law firm. For his loyal support of fellow Republicans in the mid-1960s, Nixon was rewarded again with the party's presidential nomination in 1968. This time he beat his opponent, Hubert Humphrey.

Nixon inherited the leadership of a nation violently at odds with itself over the Vietnam War, race relations, and the cultural gap festering between young Americans and the so-called establishment. Only after thousands of additional casualties and intensified bombings, and largely through the diplomacy of national security adviser Henry Kissinger, was Nixon able to achieve what he termed "peace with honor" in Vietnam. Arguably, Nixon's greatest foreign achievement was his historic trip to Communist China in 1972. This first visit of a President of the United States to the People's Republic of China opened up new dialogue and trade. With the Soviets, massive sales of American grain and the signing of a nuclear nonaggression pact signaled the age of détente in the protracted Cold War.

If ever a President's performance was ruined by the encore of a second term, it was Richard Nixon's. Although he personally had nothing to do with authorizing the 1972 break-in at the Democratic National Committee Headquarters inside the Watergate building, he was surrounded by cohorts inside the White House who involved him in a cover-up. Confronted with his own tape recordings clearly indicating the obstruction of justice, and faced with almost certain impeachment, Nixon resigned the presidency on August 9, 1974. ★

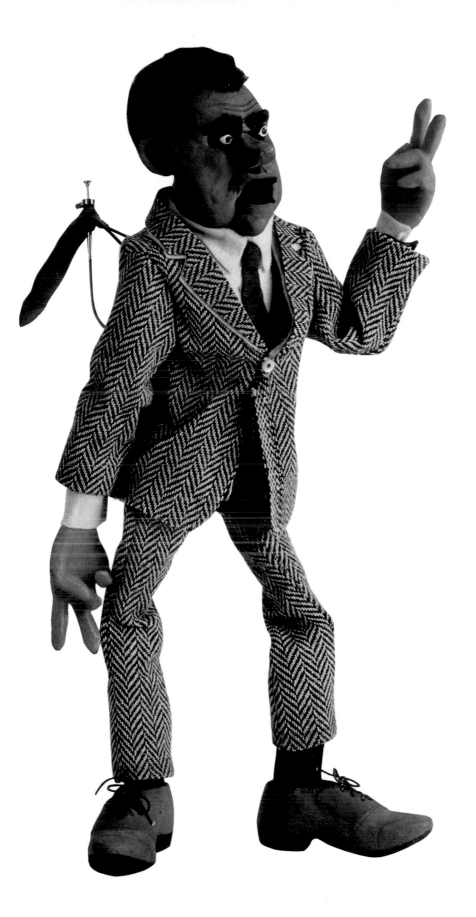

Invariably Nixon projected a stiff and awkward public persona. When giving a speech, he could be betrayed by his gestures, as noted by one recent biographer, *"for sometimes the sweep of his arms or the twists of his body or the counting of points on his long fingers seemed ill-timed with his words, as if speech and gesture had gotten out of sync, like a film running a few frames ahead or behind its sound track."* Perhaps Nixon made a similar impression upon Larry N. Frost of Denver, Colorado, who made this puppet likeness of him in 1973.
58.4 cm. (23 in.) height
Richard M. Nixon Presidential Materials, National Archives

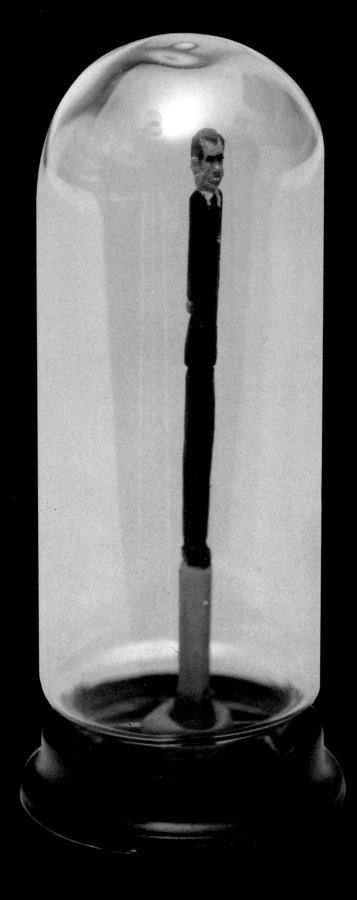

Len Bulnes of New
York City carved this
delicate figurine of
Nixon from a wooden
matchstick in 1971.
5.7 cm. (2 ¼ in.) height.
Richard M. Nixon
Presidential Materials,
National Archives

Syed M. Rizvi of
Monrovia, California,
executed these
miniature portraits of
Richard Nixon on
grains of rice and a
minute piece of
ivory and presented
them to President
Nixon in a blue
velvet case in 1971.
Ivory: 6.4 cm.
(2½ in.) oval.
Rice: 0.64 cm.
(¼ in.) sight.
Richard M. Nixon
Presidential Materials,
National Archives

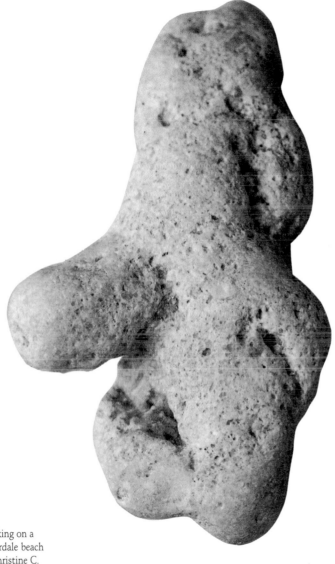

While walking on a
Fort Lauderdale beach
in 1971, Christine C.
Phillips of Forty Fort,
Pennsylvania, found
this stone, which she
thought looked like
President Nixon.
5.1 cm. (2 in.) height.
Richard M. Nixon
Presidential Materials,
National Archives

As Vice President, Richard Nixon began playing golf at the suggestion of his highly competitive boss, Dwight Eisenhower. Although never a devotee of the game, Nixon "had learned in the Navy that when your superior officer makes a suggestion, you should take it as a command." During one particular round upon which a bet had been placed, Eisenhower lost patience with his junior partner. "Look here," he said. "You're young, you're strong, and you can do a lot better than that."

Nixon let his game lapse when it no longer was a job requirement. Yet he resumed playing after he resigned the presidency. Emotionally and physically drained, Nixon found the exercise and the challenge to improve his game to be therapeutic, especially after suffering a serious bout with phlebitis in 1974. This plaster and acrylic caricature was made and presented to Nixon in 1971 by three admirers — Mary Ann Connelly, Sharon Hamilton, and Lois Schmok — from Costa Mesa, California. 53.3 cm. (21 in.) height. Richard M. Nixon Presidential Materials, National Archives

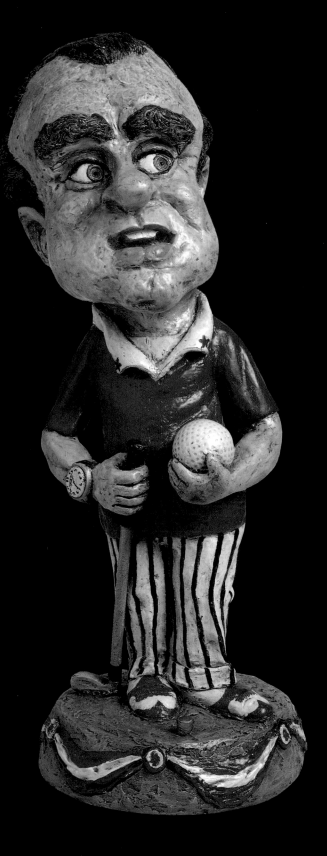

Introspective by nature, President Nixon began keeping his own counsel more and more the longer he occupied the White House. The job itself, as described by several of his more outgoing predecessors, was the loneliest one in the world. Nixon all but became a self-imposed exile in the Oval Office. He held few press conferences, sought counsel from a limited number of aides, and generally lost direct contact with the American people. For Nixon, the Watergate cover-up resulted largely from a natural inclination to hide the unpleasant facts.

Glenn Bischof of Orlando, Florida, was the donor of this 1972 work, a polyester resin and acrylic caricature of Nixon looking into a glass cube.
36.8 cm.
(14½ in.) height.
Richard M. Nixon Presidential Materials, National Archives

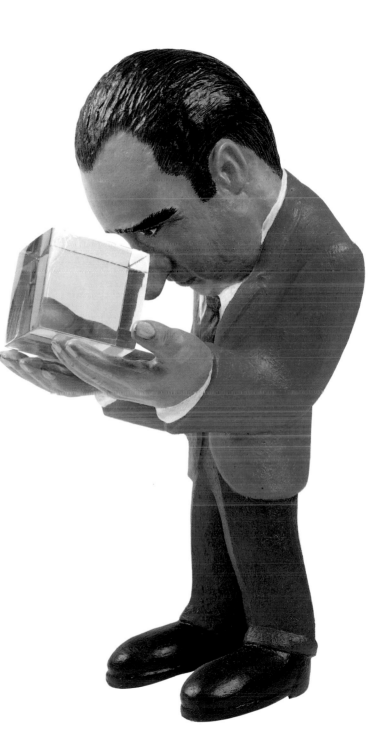

As a former University of Michigan football all-star, Gerald Ford was used to the necessity of substitutions. So it was that when President Richard Nixon's political career ended, Vice President Ford suddenly found himself in the throes of power. Ford had actually been a replacement Vice President for Spiro Agnew, who resigned in 1973 after pleading no contest for income-tax evasion. During the Watergate era of intrigue and corruption, Ford was an ideal selection to assume the duties of the presidency. His political credentials won Nixon's approval immediately. Since their days as freshmen congressmen in the late 1940s, Nixon and Ford had shared a mutual respect. Later, as minority leader in the House, Ford had been a loyal supporter of Nixon's administration. Moreover, Ford's candor and forthrightness had won him many friends in Congress from both parties. As for his personal integrity, 350 FBI agents could not find anything derogatory about his past in his home district of Grand Rapids, Michigan, or anywhere else.

After Ford took the oath of office on August 9, 1974, the nation collectively breathed a sigh of relief. For the first time in two years, Watergate stories did not dominate the front pages of daily newspapers. In the White House itself there was a new openness as pronounced as if the window shades had been suddenly thrown open. Members of the press who had been customarily excluded during Nixon's tenure were invited back under Ford. For days, as the first family settled into their new home, the media introduced them seemingly one by one to a curious national audience. First lady Betty Ford promised to be an active public figure, not to intrude upon the President's working lunches, and to continue a twenty-five-year practice of sharing the same bed with her husband in spite of their new two-bedroom suite. The three Ford sons did

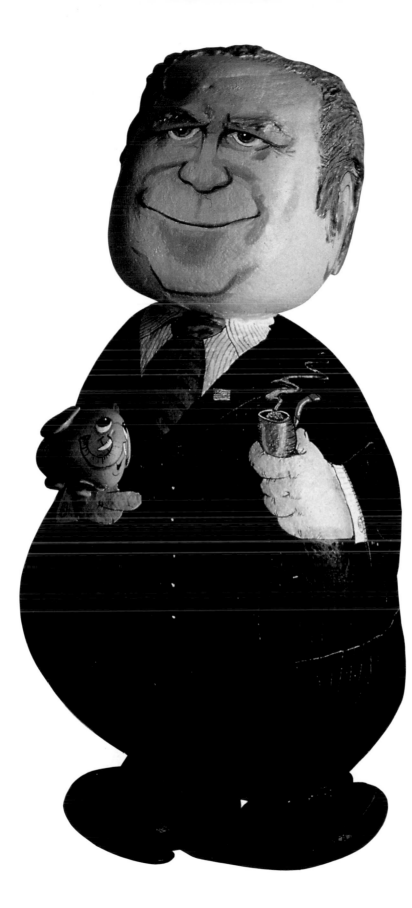

This painted rock sculpture depicts the President holding a small elephant, the Republican party mascot, in his right hand, and a pipe in his left hand.

Made from four Pennsylvania river stones, this piece weighs almost 70 pounds and was presented to Ford in 1976 by Michael Manning of Yardley, Pennsylvania. Ford himself, upon becoming President at the age of sixty-one, weighed 203 pounds, a mere 4 pounds over his football-playing weight.

48.3 cm (19 in.) height.

Gerald R. Ford Library and Museum

not expect to live in the White House, but Susan, seventeen, did, vowing never to throw away her blue jeans. As for the President himself, he continued to make his own breakfast for a while, enjoyed daily swims, and usually ended the day with a couple of dry martinis, each with a pair of olives.

Indicative of how quickly the demands of the presidency can tarnish the reputations of even the best-intentioned, Ford's grace period with the American people lasted a month, almost to the day, of his taking office. On September 8, 1974, Ford granted a full and unconditional pardon to his predecessor, Richard Nixon, for his role in the Watergate conspiracy. This surprise decision outraged many people, who accused Ford of unnecessarily interfering in the judicial process. Still other Americans had serious qualms about his subsequent decision to grant earned amnesty to Vietnam War draft dodgers and deserters. Yet it was the President's primary objective to heal the nation as he addressed the country's number-one concern — controlling runaway, double-digit inflation.

Try as he might, Ford was never successful in channeling the nation's Bicentennial spirit toward fighting this ubiquitous thief of the consumer's pocketbook. His patriotic calls for the people "to drive less, save more, spend less, hunt for bargains, work harder, plant gardens, turn off lights, keep doors closed, and clean their plates" largely went unheeded. In 1976, the majority of the electorate rejected Ford for his leniency toward Nixon, for a disturbing trend of bigger government, and for a worsening economy. History, however, will always credit Ford with restoring trust in the nation's highest office. ★

Ford's love of skiing was first brought to the public's attention in a feature article in *Life* magazine in March 1940. At the time, Ford, twenty-eight, was attending law school at Yale and was dating a beautiful blond fashion model named Phyllis Brown. It was Brown who introduced Ford to skiing. She was also the primary inspiration for the six-page illustrated article about one of their skiing weekends together in Stowe, Vermont. When Ford became President, the press resurrected this "play by play account" of the smitten young couple's holiday. Years later, the Ford family enjoyed skiing vacations at their favorite Christmastime retreat in Vail, Colorado. The circumstances behind this small oil painting of the President on the slopes are unknown, and the artist is known only as Stewart. 12.7 x 17.8 cm. (5 x 7 in.). Gerald R. Ford Library and Museum

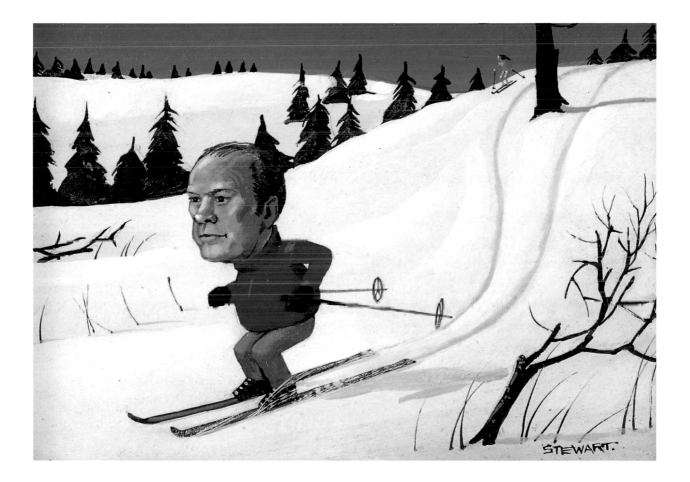

STEWART.

muffin tongs and cartoon sketches. This 1974 india ink profile caricature was a study sketch used by cartoonist Jim Berry for his popular series "Berry's World." In the published cartoon, Ford is shown greeting the White House chef, who pleads, "Please, Mr. President! I know how to cook English muffins!"
66 x 59.4 cm.
(26 x 23⅜ in.).
Gerald R. Ford Library and Museum

Ford's foremost
domestic challenge as
President was curbing
the high rate of
inflation, which was
averaging about 12
percent annually.
Toward this goal, the
President relied heavily
upon a public-relations
campaign to muster
support. With all the
fervor of a college
athletic department,
the administration
adopted the slogan
"Whip Inflation
Now", and began
pushing WIN

buttons, bonds, and
pennants. Because
inflation proved to be
both an elusive and
ubiquitous foe, this
drive to encourage
Americans voluntarily
to be thriftier, smarter
consumers was never
really successful. The
WIN campaign,
however, did provide
the inspiration for this
1975 Masonite and
acrylic cutout
caricature of Ford, by
Mario M. Barnes of
New Orleans.
25.4 cm.
(10 in.) height.
Gerald R. Ford Library
and Museum

A quintessential long shot, Jimmy Carter began his systematic quest for the White House in early 1975, as his successful term as governor of Georgia was drawing to a close. In May 1971 Carter had gained a measure of national attention when *Time* magazine ran a cover story about the new governor's assertive policies for ending racial discrimination in his native state. Except for a brief podium appearance at the Democratic National Convention in 1972, Carter remained largely unknown to the American people as he crisscrossed the country campaigning for President. The question asked by most people was "Jimmy who?" Carter provided the answer in part in a campaign biography, *Why Not the Best?* In person Carter projected himself as a sincere, easygoing peanut farmer, politician, and Christian. But most of all, in selling his southern brand of conservative populism, Carter assured the people that he would never lie to them.

Carter's election in 1976 was testament to his superbly run campaign and to his new spirit of openness that promised to let the people run government and not vice versa. The Carter style of approachability was demonstrated immediately by the new President's decision to walk down a crowd-lined Pennsylvania Avenue to the White House after his swearing-in at the Capitol. A few weeks later the White House hosted a nationally broadcast question-and-answer phone-in, in which forty-two out of nine million listeners talked to the President.

Yet the Carter administration displayed an arrogance toward Congress that was bold even by Washington standards. White House aides, in advocating the President's agenda for major initiatives like tax and health-care reforms, routinely alienated key members of the House and Senate, both of which were controlled by the President's own Democratic party. Carter was more successful in passing a minimum-wage bill, an environmental ban on fluorocarbons in aerosol sprays, and civil-service reform representing the first major

"A Tribute to Jimmy"

During the presidential campaign of 1976, Jimmy Carter made no apologies for his rural patrician roots in Plains, Georgia, or for his family's interest in peanut-farming. For instance, he christened his campaign plane "Peanut One." Americans responded in kind with all sorts of peanut-motif gifts: walking sticks, weather vanes, and this papier mâché peanut bearing another familiar Jimmy Carter trademark, a big toothy grin. Eighth-grade students Arif Akram, Michael Banks, John Oswald, and Delmar Ross at John W. Dodd Junior High in Freeport, New York, created this whimsical papier-mâché icon for the President in 1977. 41.9 cm. (16½ in.) height. Jimmy Carter Library

revision in federal employment codes since 1883. In line with Carter's commitment to more responsive government, he created two new cabinet-level departments — energy and education.

Human rights was an integral factor of Carter's foreign policy. American aid was either curtailed or denied completely to countries in which violations occurred. At one time or another, South Africa, the USSR, and several Latin American countries found themselves in disfavor with the administration. The signing of two Panama Canal treaties, essentially granting full control of the canal to Panama by the year 2000, was one of Carter's major foreign-affairs initiatives. Another was to open up historic new dialogue between Egypt and Israel, which resulted in the signing of a peace treaty in Washington in 1979, ending three decades of hostility between those two nations.

As fate would have it, Carter devoted the last fourteen months of his administration to resolving the hostage crisis in Iran. In spite of diplomatic efforts, the freezing of Iranian assets, an aborted rescue attempt, and condemnation by the international community, Iran remained resolute in holding the majority of the sixty-six Americans captured on November 4, 1979, inside the United States embassy in Tehran. Carter's self-absorption in the crisis made him a prisoner of the White House. With no resolution in sight, with inflation soaring around 16 percent, and unemployment on the rise, Carter faced insurmountable odds in winning reelection. His political career at an end, Carter greeted the freed American hostages in Wiesbaden, Germany, the day after he had transferred the powers of the presidency to his successor, Ronald Reagan. That diplomatic gesture manifested Carter's personal commitment as a private citizen toward international peace initiatives in the future. ★

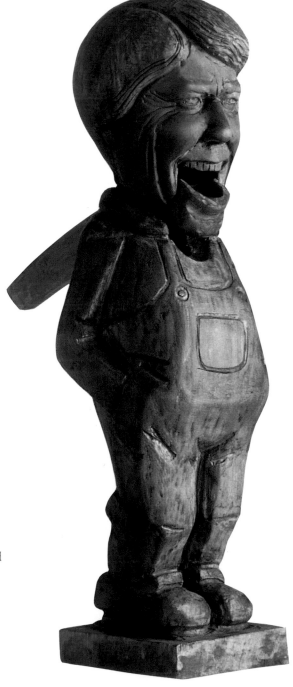

In admiration of President Jimmy Carter's Christian principles, Virgil Harbert, sixty-one, of Mitchell, South Dakota, carved this bust of the President with a light, three-pound chain saw. Harbert had taken up "whittling" as therapy for his chronic arthritis. When he lost mobility in his shoulders, he resorted to power tools to aid him in his craft. After three months and three false starts, Harbert sculpted this cottonwood bust and sent it to the President just before he left office in January 1981. Harbert described himself as a man of limited means, but he was proud of his chain-saw art. "I prefer to call them sculptures," he wrote. "It has a more cultured ring to it." 47 cm. (18½ in.) height. Jimmy Carter Library

Americans were already well acquainted with Ronald Reagan decades before he became the Republican party's presidential nominee in 1980. They had listened to his radio sports broadcasts in the 1930s, they had watched him star in Hollywood movies and on television in the 1940s and 1950s, and they had followed his rise in politics as California's governor between 1967 and 1975. An unsuccessful candidate in three previous presidential contests, Reagan emerged as the undisputed challenger in 1980. His pledge to reduce taxes and big government, and to restore the nation's prestige as a superpower, appealed to Americans dejected by double-digit inflation, a stagnant economy, and a loss of morale in the grip of international terrorism. Voters overwhelmingly responded to Reagan's geniality and wit, and accepted his sunny vision for the country.

On Inauguration Day, as President Reagan began to deliver his address, a shaft of sunlight broke through the gray, overcast January sky. First lady Nancy Reagan interpreted this as a good omen. Only moments later, official confirmation of the release of the fifty-two American hostages, held captive in Iran for 444 days, indeed proved to be fortuitous for the new President, who wasted no time in implementing his own agenda. Just minutes into office, and prior to attending a luncheon in the Capitol, Reagan issued his first executive order, a freeze on nonmilitary government hiring.

The gifted students of Floyd R. Schafer Elementary School of Nazareth, Pennsylvania, through their principal Mary Ann Moyorak, sent this framed jelly-bean portrait to President Reagan in 1988. 63.5 x 53.5 cm. (25 x 21¹⁄₁₆ in.). Ronald Reagan Presidential Library

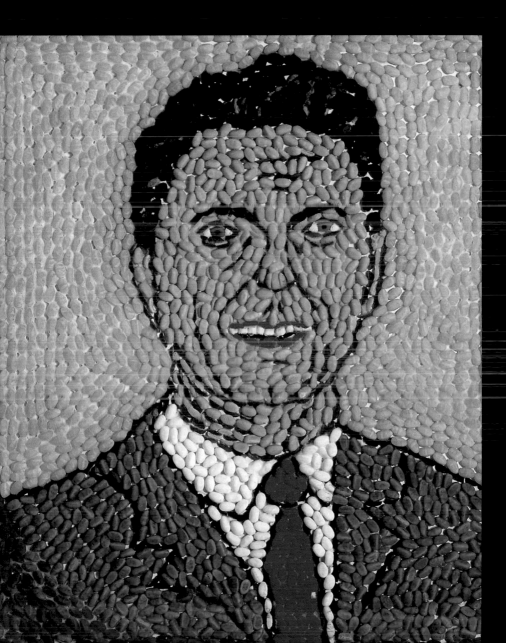

Reagan established his credibility early, in keeping his campaign promises to reduce taxes and to cut the tentacles of the federal bureaucracy. Reaganomics and deregulation became the buzzwords of the 1980s. Inflation swooped and the economy surged forward, but only after a severe recession. That Reagan was able to sell his vision of prosperity to a nation eager to believe the best was in accordance with America's credit-card mentality. Under Reagan the national debt increased by 170 percent, a staggering sum. A rejuvenated Defense Department was a big beneficiary of this spending spree, which in turn bolstered the President's hand in international relations. New leadership in the Soviet Union faced new resolve in the United States and resulted in new progress in arms reductions. Still, America's vulnerability to terrorism was painfully witnessed in Beirut, Lebanon, in 1983, where 241 Marines on a peacekeeping mission were killed in their sleep by a terrorist bomb.

Yet, like the veteran movie star that he was, Ronald Reagan had a knack for walking away from scenes of disaster without incurring a scratch upon his political reputation. His magic of projecting an aura of patriotism and honor, combined with a disengaged style of management, in large part shielded him from accusations of personal involvement in the Iran-Contra debacle. Put simply, Americans liked and trusted Ronald Reagan. His approval rating upon leaving office was a healthy 64 percent, a record high for a modern two-term President. ★

1981-1989

Ronald Reagan's fore-most challenge when he became President was bringing down spiraling inflation and jump-starting a stagnant economy. Reagan proposed to accomplish this in part by a series of tax reforms that would encourage capital investment. The basic theory behind Reaganomics, or supply-side economics, was that if producers had more money to spend, more goods and jobs would become available. Although eighteen million new jobs were created, Reagan's trickle-down prosperity never fully reached the poor and underprivileged. Steve Knittel of Ozark, Missouri, made this caricature wood carving, titled *Economic Punch,* of Reagan in 1981. 31 cm. (12³/₁₆ in.) height. Ronald Reagan Presidential Library

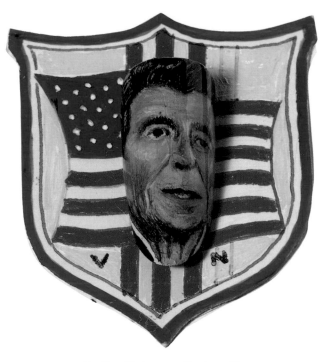

Mr. Quan Thai Nguyen sent this portrait of Reagan, painted on an acrylic fingernail-tip, to the fashion-conscious first lady, Nancy Reagan in 1986. The artist was a Vietnamese refugee living in Sewaren, New Jersey. His ambition was to become a manicurist so that he could afford to have his wife and four children join him in America. 4.4 cm. (1¾ in.) height. Ronald Reagan Presidential Library

Ronald Reagan's love for jelly beans is recorded here, with this refrigerator magnet done in 1983 by Julie Hornsby of Delaware, Ohio. The President kept a jarful of his favorite candy on his desk in the Oval Office. During Reagan's tenure, jelly beans became a national craze and were marketed in all sorts of fancy containers and in exotic flavors like watermelon, coconut, and tangerine. 7 x 4 cm. (2¾ x 1⁹⁄₁₆ in.). Ronald Reagan Presidential Library

Berta Kuznetsova of Brooklyn, New York, gave this hand-painted button portrait to President Reagan in 1985. 2.5 cm. (1 in.) diameter. Ronald Reagan Presidential Library

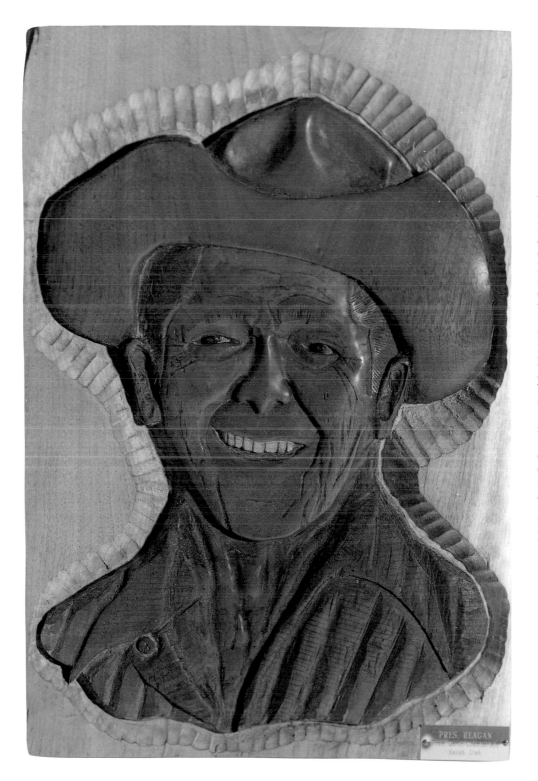

This wooden
sculpture of President
Reagan won for its
carver, Garth
Chamberlain of
Kanab, Utah, a blue
ribbon at the Kane
County Fair in 1986.
The cowboy hat
Reagan wears is in
keeping with the
President's western
heritage and his stint
as host for the "Death
Valley Days" television
series in the early
1960s. Reagan recalled
in his memoirs that
"some days, I didn't
even have to get out
of my ranch clothes
for the filming."
52 x 34.9 cm.
(20½ x 13¾ in.).
Ronald Reagan
Presidential Library

Not since Martin Van Buren had entered the White House on the coattails of Andrew Jackson 152 years earlier had a Vice President succeeded an incumbent President. In 1989 George Bush did just that, demonstrating the popularity and appeal of Ronald Reagan, as well as his own personal decency, conciliatory nature, and commitment to Republican party conservatism. Bush had always been a good man to take orders, and his twenty-five-year public career was largely at the beck and call of political incumbents. Persistence, loyalty, and a desire to serve his country had been character traits of Bush from the start. As a World War II navy fighter pilot, he had lost four planes in action, all with the name of fiancée Barbara painted on the sides of the fuselages. After the war he married Barbara Pierce, moved to Texas, and supported a budding family as a cofounder of a small but flourishing oil-drilling company. In 1967 Bush won a seat in the United States House of Representatives, which he held until 1971. What followed was a string of political appointments under Presidents Nixon and Ford. In the space of six years Bush honed his diplomatic skills as an ambassador to the United Nations (1971–1973), chairman of the Republican National Committee (1973–1974), chief of the United States Liaison Office in China (1974–1975), and director of the Central Intelligence Agency (1976–1977). By 1980 Bush decided to make a run for the White House. His résumé was up-to-date, but it lacked the clout of more politically experienced Republicans, namely staunch conservative Ronald Reagan. That year the best Bush could hope for was the vice presidency, a job he filled with dedication and enthusiasm.

Walker's Point, the family vacation home in Kennebunkport, Maine, had been a welcome summer retreat for George Bush since he was a boy. It was there that his grandfather had taught him how to handle and dock a boat and how to catch mackerel and pollack. It was a "straight-and-simple method of fishing," remembered Bush, "just a basic green line wrapped around a wooden rack with cloth from an old shirt or handkerchief used as a lure. Nothing fancy.... If the mackerel were running, they'd bite on anything." As President, Bush continued to enjoy boating and fishing during his visits to Kennebunkport. This caricature paper cutout of him fishing, with the vacation home in the background, was presented to him by Robert Carley of Purchase, New York, shortly after the President returned from a summertime visit in 1989. 27.9 x 35.6 cm. (11 x 14 in.). George Bush Presidential Materials Project

President and Mrs. Bush received these yuletide portraits of themselves, titled *Mr. and Mrs. Santa Bush,* in December 1991. Made of ceramic, velvet, and wood, they were from well-wisher Lola Adams of Scotia, New York. 55.9 cm. (22 in.) height. George Bush Presidential Materials Project

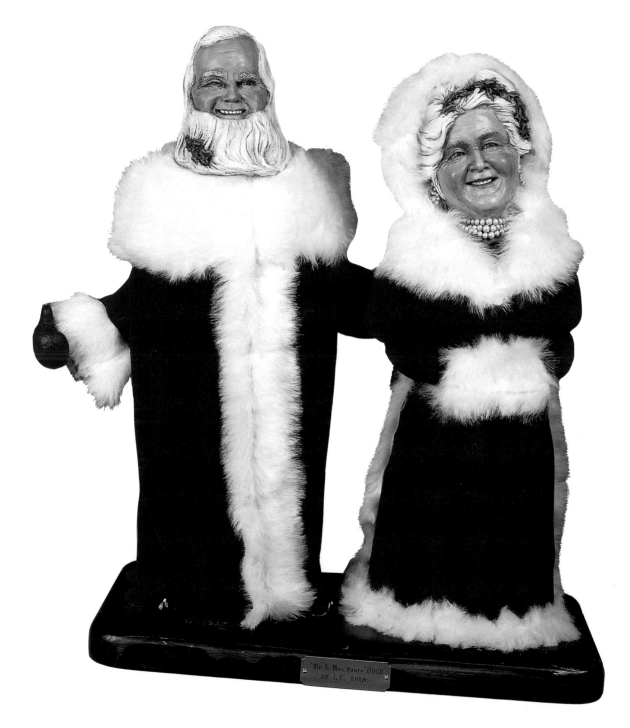

Prosperity in the 1980s and the backing of an immensely popular President were seemingly the key credentials Bush needed in 1988 to win the Oval Office. Bush campaigned largely on the momentum of Reagan's agenda of tax reform, new jobs, continued economic growth, less big government, and a strong national defense. What was not clear from the beginning, however, was an ideology that defined George Bush, a likable man with no known longstanding convictions about government's role in determining the destiny of the nation. Bush emerged from behind Reagan's long shadow seemingly poised to carry on the status quo.

Foreign affairs preoccupied the Bush administration, largely distracting it from addressing domestic issues, especially an economy that had suddenly gone flat. The Iraqi invasion of Kuwait in August 1990 tested Bush's resolve in thwarting international tyrants. His leadership in soliciting worldwide condemnation, backed by an embargo and a coalition army, was nothing less than brilliant. At the end of the Persian Gulf War in March 1991, Bush's approval rating among Americans was an unprecedented 88 percent. The collapse of the Soviet Union a few months later only seemed to validate the administration's defense policy of peace through strength.

Yet Bush had other problems mounting at home. The economic recession was the most glaring, especially following the historic expansion of the Reagan years. On the advice of his inner circle, Bush adopted a wait-and-see policy and hoped for the best. Against a partisan Congress Bush used his veto power repeatedly to his advantage. He was, however, seduced into raising taxes in 1990, thereby breaking an ardent campaign promise of no new taxes. Unlike Ronald Reagan, the "Great Communicator," who could explain away such reversals as being in the best interest of the country, the best that Bush could do was admit that he had made a mistake. Bush also paid the bill for a few of his predecessor's policy foibles. Reagan's frenzy for deregulation spawned the savings and loan scandal, which cost taxpayers billions of dollars. As for trickle-down Reaganomics, it became embarrassingly evident under Bush that such economic policy had significantly widened the gap between rich and poor.

By the time of the 1992 presidential campaign, Bush appeared more like the victim of the Reagan era, which had run out of vision and steam, than the candidate of the future. The national debt alone, an ominous four trillion dollars, was enough to induce Texas billionaire Ross Perot to enter the race as an independent. Victory, however, went to the candidate promising more change with less pain — Governor Bill Clinton of Arkansas. ★

According to the golf pro at the local club in Kennebunkport, speed and persistence were characteristics of George Bush's style of golf. Bush liked to hit the ball and keep moving; rarely did a game take more than two-and-a-half hours with a foursome. He insisted on playing through spates of rain, and hitting balls in mud was just part of his game.

This copper sculpture of Bush playing golf — entitled *Checking the Distance* — was made in 1990 by seventy-four-year-old Clinton A. McCallum, an avid golfer from Lapeer, Michigan.
55.2 cm.
(21¾ in.) height.
George Bush Presidential Materials Project

Zhao Cheng-Xin of
China painted this
portrait of President
Bush on the inside
of this small snuff
bottle in 1992.
8.6 cm. (3⅜ in.) height.
George Bush
Presidential Materials
Project

1993—

With his blue eyes trained on the White House in late 1991, Governor Bill Clinton of Arkansas turned a politically sensitive ear to the country and heard what few others could hear: the ring of opportunity. The odds of anyone defeating incumbent President George Bush in the next election seemed remote indeed, at least for the time being. In the wake of the Persian Gulf War victory and the collapse of the Soviet Union, ending four-and-a-half decades of Cold War, President Bush was enjoying unprecedented high public approval ratings. Undaunted by this euphoria and with boyish optimism, Governor Clinton began formulating his own campaign strategy, one that would focus undivided attention on the sluggish economy and recession. If a presidential candidate was seriously going to challenge Bush, it would be on these pocketbook issues that directly affected all Americans.

Bill Clinton had been preparing himself for this moment in history for most of his adult life. Given his political ambitions, he had nothing to lose and little place else he wanted to go but the White House. In 1963 he had visited there via a high school civics program for class leaders and had shaken hands with President Kennedy. Enamored by the dynamics of the nation's capital, Clinton decided on a career in politics and tailored his education and early career accordingly. After graduation from law school at Yale in 1973, where he met his future wife, Hillary Rodham, Clinton returned to his native state and began a two-year stint teaching law at the University of Arkansas. Meanwhile, he tried unsuccessfully to win a seat in the United States House of Representatives. His narrow defeat was not in vain, for it helped lay the

This chair portrait of
President Bill Clinton
was made by artist
J. Goodman shortly
after the presidential
election in November
1992. In part it is
made from an old suit
jacket, shirt, and tie,
draped over the back
of a wooden kitchen
chair. The message on
the chair seat, "Invest
and Grow," invokes
Clinton's vision for
America.
109.2 cm.
(43 in.) height.
The White House
Gift Unit

political footing for his next job, that of state attorney general. Two years later, in 1978, Clinton, at age thirty-two, became the youngest governor of a state in forty years. Voters, however, rejected him in the next election for raising gasoline and vehicle registration taxes to pay for roads. "The people sent me a message," vowed an apologetic Clinton, "and I learned my lesson." In atonement for his youthful exuberance, Clinton promised not to repeat his taxing errors if given another chance. In 1982, voters returned Clinton to the governor's mansion, where he would reside permanently until packing his bags for 1600 Pennsylvania Avenue.

As a presidential candidate, Clinton took advantage of a weak field of contenders to drive home a simple message — change. With the economy at a standstill, the deficit escalating beyond comprehension, and government staggered by partisan gridlock — in addition to the fact that Republicans had controlled the executive branch of government for the past twelve years — the political mood of the nation was susceptible to a nudge toward the left, to what Clinton defined as a centrist position. From this middle ground, Clinton proved to be a surprisingly agile candidate: a compromiser by experience, a pacifier by nature, he hated to alienate anyone. On the issues he talked in generalities; he offered plans without giving details and set goals without making promises. Critics resurrected an old label, "Slick Willie," and accused him of being all things to all people. The press badgered him about personal allegations: about the state of his marriage, about accusations of infidelity, and about dodging the draft during the Vietnam War. Shrewdly, Clinton managed to keep the focus of his campaign on the big issues, namely the economy and health-care reform. In the end, neither the incumbent President nor third-party candidate Ross Perot could significantly diminish Clinton's lead in the polls. On election day he won convincingly, a tribute to his strategic and communicative skills in reaching the American people. As President, whether he can produce the change he so persistently called for will determine the future legacy of the man and his statesmanship. ★

PRESIDENTIAL
LIBRARIES

A

B

C

D

E

F

G

H

I

J

A. In 1962, on his eighty-eighth birthday and twenty-nine years after having left the presidency, Herbert Hoover dedicated his presidential library in West Branch, Iowa. Situated a block away from the two-room cottage in which Hoover was born, the library and museum building has recently been renovated and expanded. President and Mrs. Hoover are buried nearby and within the Herbert Hoover National Historic Site complex.

B. The Franklin D. Roosevelt Library occupies sixteen acres of the President's Hyde Park estate, in close proximity to the fully furnished Roosevelt home. Built in 1939, it was turned over to the United States government the next year, and its museum opened to the public in 1941. This facility was the first of the presidential libraries and the only one to have been built and used by an incumbent President.

C. Built in Truman's hometown of Independence, Missouri, the Harry S. Truman Library became almost a second home for the retired President. He lived within walking distance and visited his office there almost daily. The museum lobby contains a large mural, *Independence and the Opening of the West* by Missouri artist Thomas Hart Benton. President and Mrs. Truman are buried in the library's courtyard.

D. After the presidency, Dwight Eisenhower retired to his farm in Gettysburg, Pennsylvania. Yet he established his library in his boyhood hometown of Abilene, Kansas. The Eisenhower Center includes separate library and museum buildings, the Eisenhower home, and a chapel-like memorial called the Place of Meditation, where President and Mrs. Eisenhower are buried.

E. The John F. Kennedy Library and Museum at Columbia Point, Boston, is housed in a modern building designed by I. M. Pei. This facility, given to the United States government in 1979, holds 32 million documents, 11,000 serials, and 150,000 photographs related to the life and times of the thirty-fifth President.

F. In May 1971, with more than 3,000 dignitaries in attendance, including President Richard Nixon, Lyndon Johnson dedicated his library on the campus of the University of Texas at Austin. Dwarfed only by the colossal football stadium nearby, the building and its collections are monumental in size and scope.

G. The Richard Nixon Library and Birthplace opened in July 1990, and is one of two presidential libraries (the Rutherford B. Hayes Library in Fremont, Ohio, is the other) not administered by the National Archives and Records Administration. This historic site in Yorba Linda, California, about thirty miles southeast of Los Angeles, attracts some two hundred thousand visitors annually and is situated on land once owned by the ex-President's father, Frank Nixon.

H. The Gerald R. Ford Museum was dedicated in 1981. Situated in Ford's hometown of Grand Rapids, Michigan, the museum examines the life and career of the thirty-eighth President through exhibitions and audiovisual presentations.

A popular attraction is the full-scale replica of the President's Oval Office. The Gerald R. Ford Library houses the public papers of Ford and is located in a separate facility on the North Campus of the University of Michigan in Ann Arbor.

I. Founded in 1986, the Jimmy Carter Library in Atlanta, Georgia, was the eighth of the presidential libraries to have been built with private donations and dedicated to the American people. In addition to exhibitions on the early life and public career of Jimmy Carter, the library has on display — behind what amounts to a wall of glass, three stories tall and fifty-five feet wide — 3,016 gray archival storage boxes, containing some of the millions of documents that in part comprise the record of the Carter administration.

J. Dedicated in 1991, the Ronald Reagan Library is quickly becoming a major attraction for tourists and researchers visiting California's Simi Valley — a forty-five-minute drive from downtown Los Angeles. Although the site lacks a personal connection to the President, the facility's architecture evokes Reagan's western heritage, while chronicling his life and diverse career in its collections and exhibitions.

The George Bush Library and Museum is being built on the campus of Texas A&M University, College Station, and is expected to open in early 1997.

INTRODUCTION

"I have no more wall space," in William J. Stewart and Charyl C. Pollard, "Franklin D. Roosevelt, Collector," *Prologue* 1 (Winter 1969): 13, 21. "Great Pyramid of Austin," in Richard Harwood and Haynes Johnson, *Lyndon* (New York, 1973), pp. 151–53. "The pretty things," in Harry S. Truman, *Off the Record: The Private Papers of Harry S. Truman,* ed. Robert H. Ferrell (New York, 1980), p. 73.

HERBERT HOOVER

"No banker, no great industrialist," George Sokolosky in Arthur M. Schlesinger, Jr., *The Age of Roosevelt: The Crisis of the Old Order, 1919–1933* (Boston, 1956), p. 459. "You just happened to be the man," in William R. Brown, *Imagemaker: Will Rogers and the American Dream* (Columbia, Mo., 1970), p. 147.

FRANKLIN D. ROOSEVELT

"I wanted to give you something on your birthday," Adolph van Hollander to Roosevelt, January 17, 1940, Roosevelt Papers, Roosevelt Library. "I have developed it," Robert L. Brown to Roosevelt, April 4, 1942, *ibid.*

HARRY S. TRUMAN

"Most fabulous accident" in Robert S. Allen and William V. Shannon, *The Truman Merry-Go-Round* (New York, 1950), p. 3. "There was an innocent idealist," in Robert H. Ferrell, ed., "Truman at Potsdam," *American Heritage* 31 (June–July 1980): 47.

LYNDON BAINES JOHNSON

"As a restless, expansive, manipulative," in Robert Dallek, "My Search for Lyndon Johnson," *American Heritage* 42 (September 1991): 87. "The greatest President of them all," in Geoffrey C. Ward, "The Full Johnson," *ibid.,* p. 14. "I regarded those laws," in Lyndon Baines Johnson, *The Vantage Point: Perspectives of the Presidency, 1963–1969* (New York, 1971), p. 329. "Make *anything* out of *anything*" is from a collection of newspaper clippings about Baggi, registrar's files, Johnson Library.

RICHARD M. NIXON

"For sometimes the sweep," in Tom Wicker, *One of Us: Richard Nixon and the American Dream* (New York, 1991), p. 23. "Had learned in the Navy," Richard Nixon, *In the Arena: A Memoir of Victory, Defeat, and Renewal* (New York, 1990), p. 161. "Look here," *ibid.*

GERALD R. FORD

"To drive less, save more," Berkeley Rice, "Fighting Inflation with Buttons and Slogans," *Psychology Today* 8 (January 1975): 49.

JIMMY CARTER

"With this nutcracker you can crack," Christoph Wagner to Jimmy Carter, January 18, 1978, Jimmy Carter Papers, Carter Library. "I prefer to call them sculptures," Virgil Harbert questionnaire, 1985, *ibid.*

RONALD REAGAN

"Some days, I didn't even," Ronald Reagan, *An American Life* (New York, 1990), p. 138.

GEORGE BUSH

"Straight-and-simple method of fishing," George Bush with Victor Gold, *Looking Forward: An Autobiography* (New York, 1988), p. 29.

BILL CLINTON

"The people sent me a message," in Louise Mooney, ed., *Newsmakers: The People Behind Today's Headlines,* vol. 1 (Detroit, Mich., 1992), p. 28.

GENERAL WORKS

Barber, James D. *The Presidential Character: Predicting Performance in the White House.* 2d ed. Englewood Cliffs, N.J.: Prentice-Hall, 1977.

Leuchtenburg, William E. *In the Shadow of FDR: From Harry Truman to Ronald Reagan.* Ithaca, N.Y.: Cornell University Press, 1983.

Neustadt, Richard E. *Presidential Power: The Politics of Leadership from FDR to Carter.* New York: John Wiley, 1980.

HERBERT HOOVER

Hoover, Herbert. *The Memoirs of Herbert Hoover.* 3 vols. New York: Macmillan Company, 1951–1952.

Robinson, Edgar Eugene, and Vaughn Davis Barnet. *Herbert Hoover: President of the United States.* Stanford, Calif.: Hoover Institution Press, 1975.

FRANKLIN D. ROOSEVELT

Burns, James MacGregor. *Roosevelt.* 2 vols. New York: Harcourt Brace Jovanovich, Inc., 1956, 1970.

Freidel, Frank. *Franklin D. Roosevelt: A Rendezvous with Destiny.* Boston: Little, Brown and Company, 1990.

Morgan, Ted. *FDR: A Biography.* New York: Simon and Schuster, 1985.

HARRY S. TRUMAN

Ferrell, Robert H., ed. *Off the Record: The Private Papers of Harry S. Truman.* New York: Harper and Row, 1980.

McCullough, David. *Truman.* New York: Simon and Schuster, 1992.

DWIGHT D. EISENHOWER

Ambrose, Stephen E. *Eisenhower.* 2 vols. New York: Simon and Schuster, 1983–1984.

Eisenhower, Dwight D. *The White House Years: Mandate for a Change, 1953–1956.* Garden City, N.Y.: Doubleday, 1963.

JOHN F. KENNEDY

Paper, Lewis J. *The Promise and the Performance: The Leadership of John F. Kennedy.* New York: Crown Publishers, Inc., 1975.

Sorensen, Theodore C. *Kennedy.* New York: Harper and Row, 1965.

LYNDON BAINES JOHNSON

Conkin, Paul K. *Big Daddy from the Pedernales: Lyndon Baines Johnson.* Boston: Twayne Publishers, 1986.

Johnson, Lyndon Baines. *The Vantage Point: Perspectives of the Presidency, 1963–1969.* New York: Holt, Rinehart and Winston, 1971.

RICHARD M. NIXON

Nixon, Richard M. *The Memoirs of Richard Nixon.* New York: Grosset and Dunlap, 1978.

Wicker, Tom. *One of Us: Richard Nixon and the American Dream.* New York: Random House, 1991.

GERALD R. FORD

Ford, Gerald R. *A Time to Heal.* New York: Harper and Row and Readers Digest Association, 1979.

terHorst, Jerald F. *Gerald Ford and the Future of the Presidency.* New York: The Third Press, 1974.

JIMMY CARTER

Abernathy, M. Glenn, et al., eds. *The Carter Years: The President and Policy Making.* New York: St. Martin's Press, 1984.

Carter, Jimmy. *Keeping Faith: Memoirs of a President.* New York: Bantam Books, 1982.

RONALD REAGAN

Reagan, Ronald. *An American Life.* New York: Simon and Schuster, 1990.

Wills, Garry. *Reagan's America: Innocents at Home.* Garden City, N.Y.: Doubleday, 1987.

GEORGE BUSH

Bush, George, with Victor Gold. *Looking Forward: An Autobiography.* New York: Bantam Books, 1988.

Duffy, Michael, and Dan Goodgame. *Marching in Place: The Status Quo Presidency of George Bush.* New York: Simon and Schuster, 1992.

Green, Fitzhugh. *George Bush: An Intimate Portrait.* New York: Hippocrene Books, 1989.

BILL CLINTON

Allen, Charles F., and Jonathan Portis. *The Comeback Kid: The Life and Career of Bill Clinton.* New York: Carol Publishing Group, 1992.

Moore, Jim, with Rick Ihde. *Clinton: Young Man in a Hurry.* Fort Worth, Tex.: The Summit Group, 1992.

Italicized page numbers
refer to illustrations.

Adams, John D., 13
Adams, Lola, 82
Akram, Arif, 71
Art Institute of Chicago, 26

Bacall, Lauren, 39
Baggi, Giuseppe, 54–55
Banks, Michael, 71
Barnes, Mario M., 69
Benton, Thomas Hart, 91
Berry, Jim, 68
Berryman, Clifford K., 23
Berryman, James T., 29
Bischof, Glenn, 62
Blackburn, Dora, 4, 46
Bolivar, Simon, 10
Borglum, Gutzon, 29
Brandt, Raymond, 29
Brezhnev, Leonid, 10
Brown, Phyllis, 66
Brown, Robert L., 29, 33
Buchanan, James, *11*
Bulnes, Len, 60
Bush, Barbara Pierce, 80, *84*
Bush, George, 18, 80–85, *81, 82, 84, 85*; library, 16

Carley, Robert, 80, 81
Carter, Jimmy, 16, *17*, 70–73, *71, 72, 73*, 91; library, 17, *91*
Castro, Fidel, 47

Chamberlain, Garth, 79
Chiang Kai-shek, 26
Churchill, Winston, 18, 26, 39
Clay, Henry, 50
Cleveland Museum of Art, 26
Clinton, Bill, 18, 83, 86–88, *87*
Clinton, Hillary Rodham, 86
Cold War, 18, 26, 43, 47, 58, 86
Connelly, Mary Ann, 63
Contreras, Carlos J., 33
Cooper, Bernie, 24, 26, 27

Davidson, David, 11
Dewey, Thomas E., 39
Diatsintos, Christos, 38, 39
Dodd, John W., Junior High, 71

Eisenhower, Dwight, *5, 14*, 15, 18, 23, 40–45, *41, 42, 44*, 47, 63, 91; library, *90*, 91
Eisenhower, Mamie, *45*, 91

Fair Deal, 36
Ford, Betty, 64
Ford, Gerald, 64–69, *65, 67, 68, 69*, 80, 91; library, *90*, 91
Fowler, Charles Evan, 23
Frost, Larry N., 59

Georges, Renier, 4, 40
Goodman, J., *87*
Grandma Moses, 39
Grant, Julia, 10
Grant, Ulysses S., 10
Great Depression, 21
Great Society, 50
Great Sphinx, 26, 28, 29
Greenhouse, Abraham, 49
Gridiron Club, 26, 29

Hamilton, Sharon, 63
Harbert, Virgil, 73
Harrison, Benjamin, *11*
Henry Morrison Flagler
 Museum, 26
Herblock, 15
Hirschfeld, Al, 17
Hoover, Herbert, 15, 16, 18, 20–23, *20, 22, 23*, 91; library, *90, 91*
Hoover, Lou Henry, 22
Hornsby, Julie, 78
Humphrey, Hubert, 58

Jackson, Andrew, 10, *11*, 80
Jefferson, Thomas, 10
Johnson, Lyndon B., 15, 16, 18, 49, 50–55, *51, 52, 53, 54, 55*, 91; library, 15–16, 18, *90*, 91
Joseph, Leo, 29
Jurden, Jack, 52

Kennedy, John F., *1*, 18, 46–49, *46, 48, 49*, 58, 86, 91; library, *90*, 91
Kennedy, Joseph P., 47
Khrushchev, Nikita, 43
Kissinger, Henry, 58
Knittel, Steve, 77
Korean War, 43
Kuznetsova, Berta, 78

Landry, Pierre Joseph, 11
Lincoln, Abraham, 10
López Portillo, José, 17
Los Angeles City Museum of
 History, Science, and Art, 26
Louis-Philippe, King, *11*

McCallum, Clinton A., 84
McErlean, R. J., 49
Manning, Michael, 65
Mehta, Usha Prataprai, 43
Mitchell, Bee, 14
Mole, Arthur S., 13
Moyorak, Mary Ann, 75

National Archives and Records
 Administration, 16, 18, 91
National Portrait Gallery, 9, 10, 18
New Deal, 24, 36, 40
New Frontier, 49
Nixon, Richard, 10, 16, 47, 56–63, *57, 59, 60, 61, 62, 63*, 64, 66, 80, 91

Ocampo, Octavo, 17
Oswald, John, 71

Patent Office Building, 10
Pearl Harbor, Hawaii, 29
Perot, Ross, 83, 88
Perry, Matthew, 10
Persian Gulf War, 83, 86
Phillips, Mrs. Charles A., 22
Phillips, Christine C., 62
Pierce, Franklin, 10
Preston, James D., 28, 29

Quan Thai Nguyen, 78

Reagan, Nancy, 74, 78
Reagan, Ronald, 15, 16, *19*, 72, 74–79, *75*, *77*, *78*, 79, 80, 83, 90; library, 16, *91*
Red Jacket, *9*
Rizvi, Syed M., 61
Rogers, Will, 21
Roosevelt, Eleanor, 24, 30
Roosevelt, Franklin, *8, 14*, 15, 18, 22, 24–33, *25*, *27*, *28*, *30*, *31*, *32*, *33*, 34; library, 15, 18, 26, *90*, 91
Roosevelt, Sara Delano, 29
Rosenstein, Nettie, 45
Ross, Delmar, 71

Schafer, Floyd R., Elementary School, 18, 75
Schmock, Lois, 63
Sherman, Beatrix, 26, 31
Smith, Bryce B., 37
Spoerl, J. P., 30
Stalin, Joseph, 26, 39

Thorne, Sallee, 45
Truman, Bess, 39, 91
Truman, Harry, 15, 16, *17*, 23, 34–39, *35*, *36*, *37*, *38*, *39*, 68, 91; library, 16, 37, *90*, 91

Van Buren, Martin, 80
van Hollander, Adolph, 24, 25
Vartazaroff, Leff, 20, 22
Victoria, Queen, 11
Vietnam War, 43, 53, 58, 66, 88

Wagner, Christoph, 72
Washington, Bushrod, 10
Washington, George, *9*, 10, 12, 40
Washington, Martha, 10
Watergate, 56, 58, 62, 64, 66
White House, 10, 17, 18, 22, 24, 34, 39, 50, 54, 58, 62, 66, 68, 70, 72, 80, 86
Whitehurst, Herman A., 39
World War II, 18, 23, 29, 36, 40, 80

Yarbrough, Roxanna, 57
Yuranyi, Steve, 52

Zesch, Gene, 51
Zhao Cheng-Xin, 85

Antoni Dolinski: pp. 19, 60, 61, 62 (Nixon stone), 75, 77, 78, 79
Maureen Gates, Sharp Images: pp. 8, 14 (ivory nut Roosevelt), 25, 30 (bronze head), 31, 32, 33
Allen Goodrich: pp. 1, 46
Henry Groskinsky: cover, pp. 25, 27, 28, 30 (Roosevelt pipe), 35, 36, 37, 48, 49, 52, 59, 65, 71, 72, 73
Charles Heiney: pp. 67, 68, 69
Howard Horan Studio: pp. 20, 22, 23
Patrick Keeley: pp. 51, 53, 54, 55, 81, 82, 84, 85
Michael Mihalevich: 17 (Hirschfeld caricature), 38, 39
Robert Pall: pp. 14 (Eisenhower bottle stopper), 41, 42, 44, 45
Rolland White: pp. 10, 11 (Benjamin Harrison), 57, 62 (Nixon looking in cube), 63, 87

Edited by Frances K. Stevenson and Dru Dowdy.
Book design by Grafik Communications Ltd., Alexandria, Virginia.
The text for this book has been set in Schneidler,
designed by F. Schneidler in 1936. Dates are set in Times.
Separations and printing by Palace Press International, Singapore.